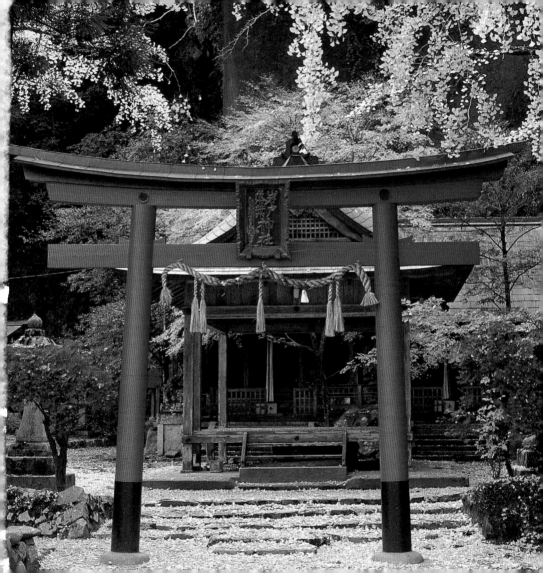

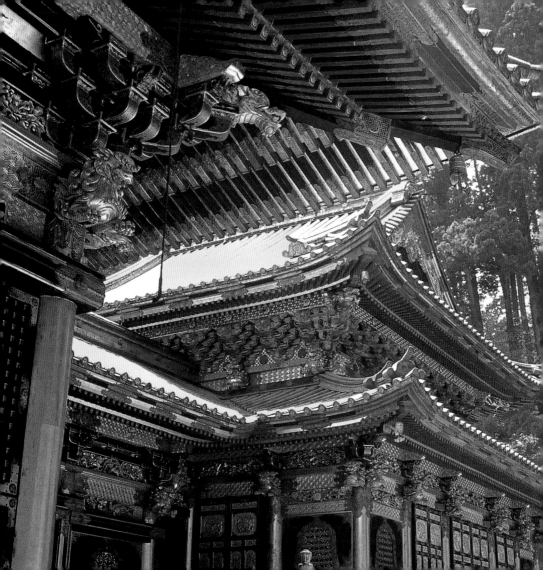

The Little Book of
Japan

Photographs by Gorazd Vilhar
Text by Charlotte Anderson

TUTTLE Publishing

Tokyo | Rutland, Vermont | Singapore

Published by Tuttle Publishing, an imprint of Periplus Editions (HK) Ltd

www.tuttlepublishing.com

ISBN: 978-4-8053-1213-1

Distributed by
North America, Latin America & Europe
Tuttle Publishing
364 Innovation Drive,
North Clarendon, VT 05759-9436, USA
Tel: 1 (802) 773-8930
Fax: 1 (802) 773-6993
info@tuttlepublishing.com
www.tuttlepublishing.com

Japan
Tuttle Publishing
Yaekari Building, 3rd Floor, 5-4-12 Osaki,
Shinagawa-ku, Tokyo 141-0032
Tel: (81) 3 5437-0171
Fax: (81) 3 5437-0755
sales@tuttle.co.jp; www.tuttle.co.jp

Asia Pacific
Berkeley Books Pte Ltd
3 Kallang Sector, #04-01,
Singapore 349278
Tel: (65) 67412178; Fax: (65) 67412179
inquiries@periplus.com.sg
www.tuttlepublishing.com

22 21 20 19 8 7 6 5 4

Printed in China 1906RR

Front endpaper A *noren* curtain hangs in the doorway of a country-style restaurant.

Back endpaper Banners bearing he names of *sumo* wrestlers and sponsors hang in front of a tournament at Ryogoku Arena, Tokyo.

Page 1 A red *torii* arch gate stands out against yellow autumn leaves at a Kyoto Shinto shrine.

Page 2 The highly decorative Taiyu-in-byo, the mausoleum of Tokugawa Iemitsu, is set in the forest in Nikko.

Right Shinto priests file in procession at Ise Grand Shrine in Mie Prefecture.

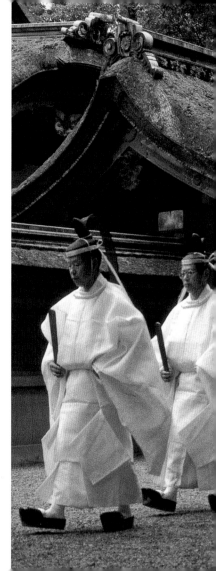

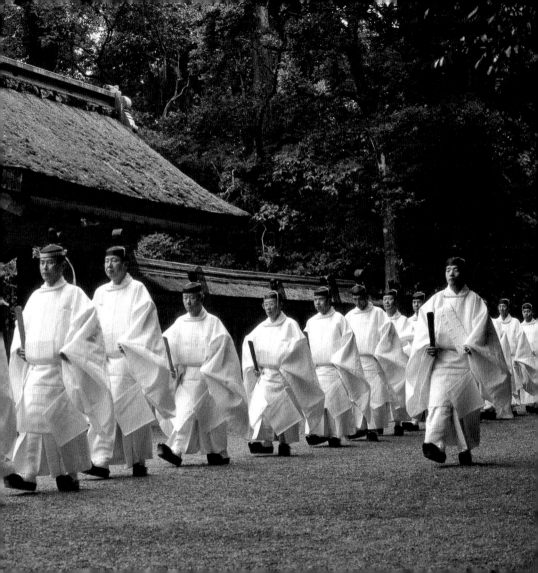

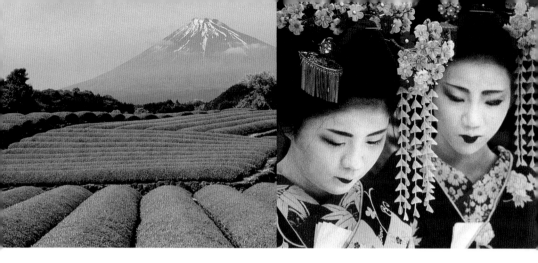

Above, left to right
Shizuoka tea fields spread below Mount Fuji; apprentice *geisha* (*maiko*) participate in an outdoor tea ceremony; a round window of a teahouse looks out on the garden at Ritsurin Koen in Takamatsu, Shikoku; Kyoto's important Heian Grand Shrine is surrounded by cherry blossoms in spring.

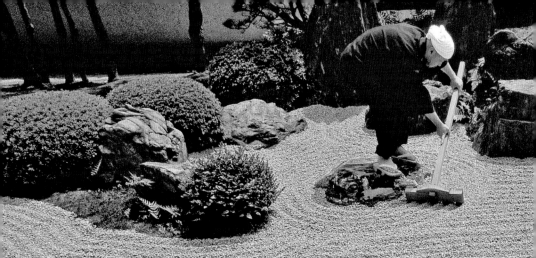

CULTURAL ICONS

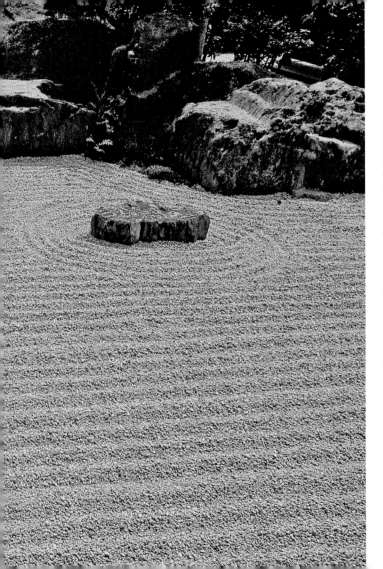

Many aspects of Japan, richly endowed with nature and with a unique culture, have become widely recognized around the world as symbols of the country. Among the creative arts there is a reputation for perfection and for the practitioners' investment of decades of effort toward mastery.

Certain icons are valued not only for their intrinsic beauty but for the fact that they were found to be worthy of appreciation. In some cases, that appreciation itself evolved into a kind of honored art form.

A monk serving as gardener at the Buddhist temple Myoman-ji in Kyoto rakes representative patterns in the gravel of the dry landscape garden.

bonsai

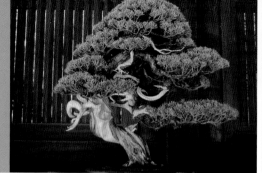

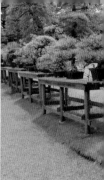

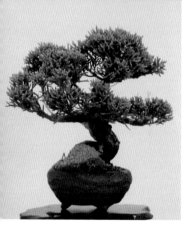

Above A mini *bonsai* pine at a hobbyist exhibition.

Right A family-operated nursery, one of a group of eleven at Bonsai Village, Omiya.

Bonsai refers to the skill and art of dwarfing trees and bushes as well as to the potted plants themselves. Originating in China as a thousand-year-old aristocratic art form of a miniature tray landscape, *bonsai* was introduced to Japan around the twelfth century, at about the time Zen Buddhism was adopted.

Bonsai is considered a creation of the microcosm of nature. Practitioners require a decade to learn the basics of maintenance, which involves root and branch pruning, wiring and shaping of branches, repotting and watering. With proper care, the trees can eventually become a treasured family heirloom over many generations, carrying memories of family ancestors and evoking a sense of continuity and eternity. As an ever-changing piece of nature, a *bonsai* plant is considered to be a living artwork. To be properly appreciated, four elements have to be considered: the choice of pot or tray, the spread of the roots, the shape of the trunk and the balance of the branches.

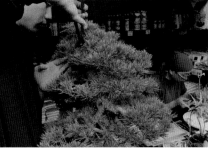

Far left An old *bonsai* treasure is exhibited at Meiji Shrine's Spring Grand Festival in Tokyo.

Center left An array from the *bonsai* collection of the Tokyo garden Happo-en.

Left Gardeners work at Bonsai Village, eleven nurseries dating from the early twentieth century.

Below A Chinese juniper is part of a Tokyo hobbyist mini *bonsai* exhibit.

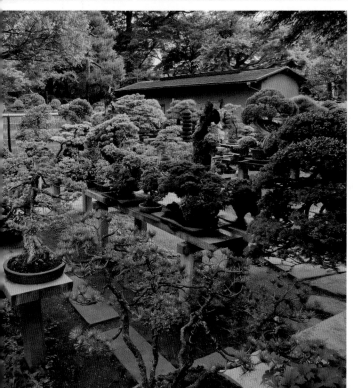

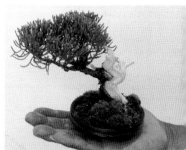

Above A bear willow (*kuma yanagi*) on display at a Tokyo hobbyist mini *bonsai* exhibit.

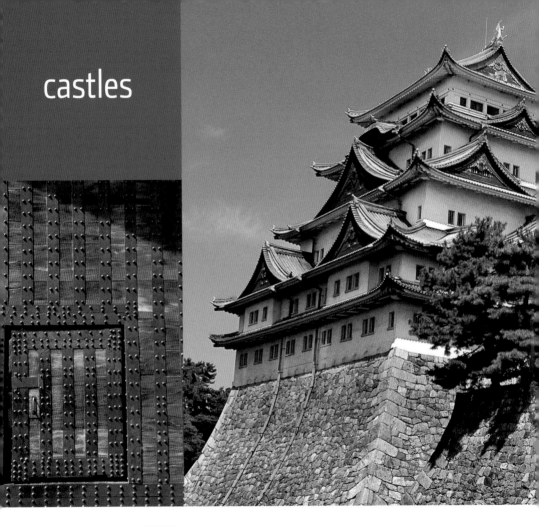

castles

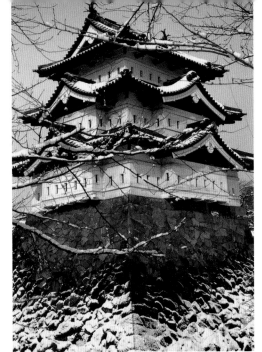

Left Nagoya Castle in Aichi Prefecture.

During the feudal era (1185–1868), when the ablest of *samurai* rose to lead their own domains as *daimyo* or overlords, owing their allegiance to the great *shogun* ruler, simple hilltop fortresses were transformed into architecturally impressive castles called *shiro*, not only magnificent residences but also formidable governing centers of castle towns.

Castles once numbered in the hundreds across the country. Some *daimyo* owned several in their domains. Out of a sense of self-protection, at one point the *shogun* restricted each *daimyo* to only one in the main locale of his residence. Under the "one castle per province" policy, many had to be dismantled by their owners.

Time also took its toll and many castles fell into disrepair, particularly once the nation entered "modern times" following the Meiji Restoration (1868–1912), and they seemed to remind people of the happily bygone feudalistic days. Others were lost to bombing during World War II because they had often been occupied by the military to store munitions, and thus became "targets." Castle ruins remain in many provincial towns, but actual still-standing castles with intact towers (*tenshukaku*) number only twelve today.

Above Hirosaki Castle in Aomori Prefecture.

Opposite far left Ironwork reinforces and decorates a gate and door at Edo Castle in the heart of Tokyo.

Below A swan paddles along the moat of Matsumoto Castle in Nagano Prefecture.

Right Himeji Castle framed by weeping willow fronds.

Center right Korakuen Castle reflected in the Asahi River in Okayama.

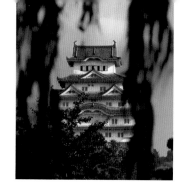

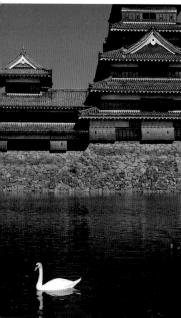

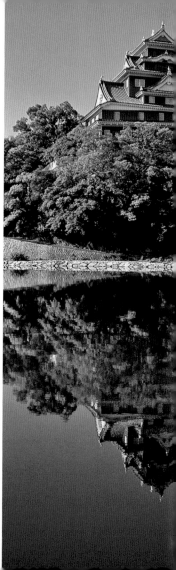

The number of *tenshukaku* symbolized a *daimyo*'s power. Sometimes extra gables were added to confuse the enemy about the castle's actual size. The construction could appear quite decorative, with windows of various shapes, beautiful tiling, family crests, ornamental gates, doors with decorative iron-work—touches one might not expect warriors to appreciate. But *samurai* were often well trained in aesthetics through such activities as the tea ceremony, calligraphy, gardening, poetry and Noh drama as a respite from the martial aspect of their lives.

Japan's remaining castles are carefully tended as symbols of Japan's rich cultural heritage and to encourage both domestic and international tourism.

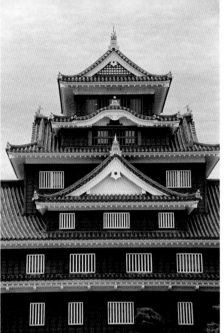

Left Korakuen Castle in Okayama, nicknamed "Crow Castle" for its dark color.

Top right Triangular shooting apertures line a castle staircase.

Center right Gables not only added beauty to castle architecture but sometimes served to confuse attacking enemies about the number of floors within.

Below Partially restored Himeji Castle, nicknamed "Heron Castle" for its white color, is seen here over tiled castle walls.

Above A pine tree stands in front of a stone castle foundation.

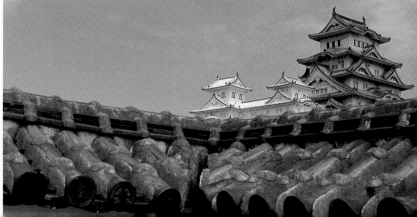

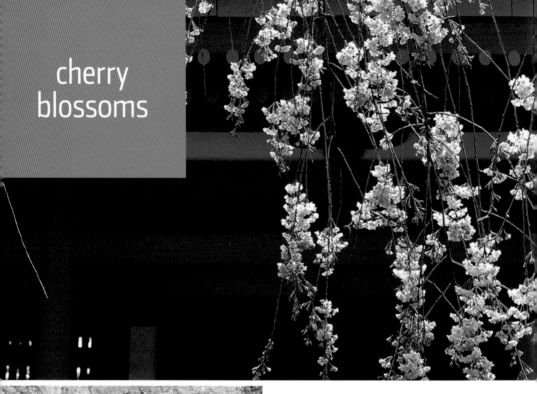

cherry blossoms

Above Blooms at Kyoto's Heian Shrine.

Left A majestic tree in Kyoto's Imperial Park.

Right A cluster of blossoms (*kawazu-zakura*) in Izu.

Above A weeping cherry tree at Kyoto's Heian Shrine.

Right Visitors celebrate *o-hanami* in Kakunodate, Akita Prefecture.

Ever since wild flowering cherry trees found growing in the foothills around Nara and Kyoto were transplanted to the Heian capital's formal gardens over a thousand years ago, spring in Japan has never been the same. As cloud-like canopies of cherry blossoms (*sakura*) spread across gardens, parks and riverbanks, a certain giddiness overtakes the land and celebration becomes the order of the day. Once only an aristocratic diversion, by the seventeenth century the common people too had discovered the pleasures of honorable flower viewing or *o-hanami*. By the millions, the population happily succumbs to

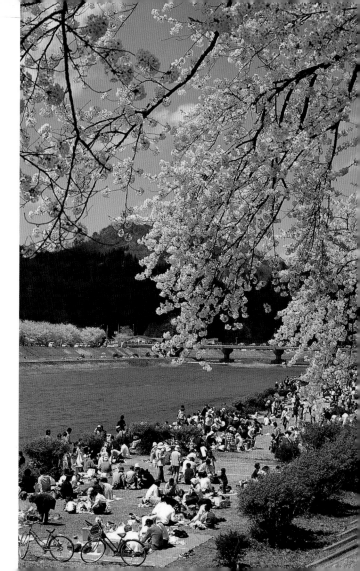

Below A red drum bridge spanning a castle moat in Yonezawa, Yamagata Prefecture, is a stark contrast to the pale pink of blossoms.

Left Early blooming *kawazu-zakura* in Izu.

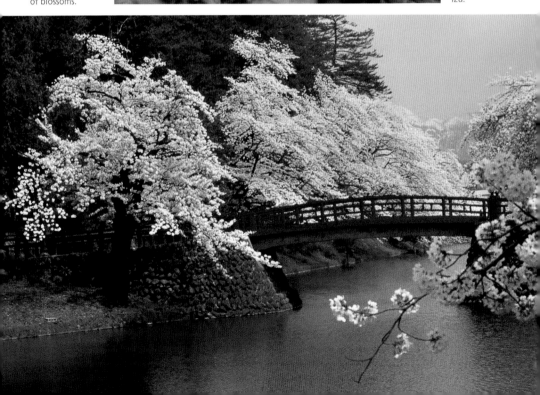

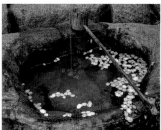

Left Fallen petals float on a pond in Ueno Park, Tokyo.

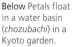

Below Petals float in a water basin (*chozubachi*) in a Kyoto garden.

the irresistible allure of this harbinger of spring. Issa, *haiku* poet of old, once put brush to paper with this sentiment:

We human beings
Squirming about among
The flowers that bloom.

Although written long ago, Issa could just as well have been writing of each year's jostling, merry crowds at Tokyo's Ueno Park, Kyoto's Heian Shrine, or any of a multitude of celebrated viewing spots across the country.

The advancing "wave" of blooming trees from Okinawa in the far south to Hokkaido in the north, its stages enthusiastically reported by the media, can last nearly two months, although the life span of

the delicate blossoms is actually little more than a week. Aside from its astonishing beauty, it is this very brevity that endears the flower to the Japanese. It is the most perfect of blooms, they say, possessing much-valued purity and simplicity. And when the petals fall, they seem to poignantly embody Buddhist thought about the ephemeral nature of life.

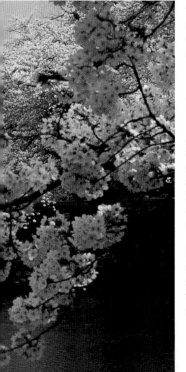

CULTURAL ICONS 19

gardens

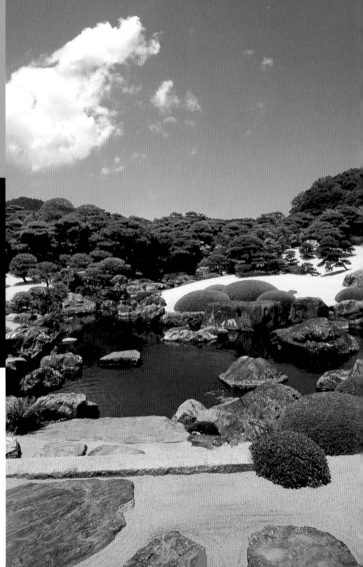

Above The round window (*yoshino mado*) of the teahouse Muji-an looks out on the gardens of Ritsurin Koen in Takamatsu, Shikoku.

Japanese garden art remains unsurpassed throughout the world. From earliest times, magnificent trees and rocks were seen as dwelling places of the divine. The predecessor of the garden concept was the early place of worship—a sacred clearing in a grove of trees. As early as the eighth century, evidenced by poetry of the time, gardens imitating natural vistas were constructed along the lines of T'ang gardens observed by court emissaries to China. The Japanese have been creating wonderful gardens (*niwa*) ever since.

In time, Buddhism, thanks to its greatly expanding popularity and imperial and aristocratic patrons, accumulated great power and wealth. With their substantial means, temples commissioned fine works of sacred art—sculptures, scrolls and paintings. Wondrous gardens were also created. These cultivated spots stood in contrast to the areas of abundant and untamed nature that then surrounded them.

Frequently created by the priests and monks themselves, many of the gardens sought to present a glimpse of Paradise on Earth. Rare rocks and careful plantings created beautiful

scenes infused with several layers of meaning. Some gardens emphasized changing landscapes as a viewer moved along a designated path. Others were meant to be seen through the enhancing frame of a window or open door, bringing adjacent or sometimes distant vistas into the overall "picture" in a technique known as *shakkei* or "borrowed scenery."

Left The garden of the Kyoto residence-museum of the late great garden designer Mirei Shigenori.

Above right The dry landscape garden at Kyoto's Kanchi-in, a subtemple of To-ji.

Opposite right The garden at Adachi Museum of Art in Shimane Prefecture.

Below A sea of raked gravel at Kyoto's Buddhist temple Zuiho-in.

Below The sand cone in the dry landscape garden at Ryosoku-in symbolizes Mount Sumeru, the center of the universe in Buddhist cosmology.

Bottom Stones represent a flowing stream at Kyoto's Shinnyo-in Temple.

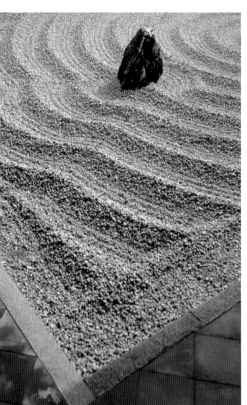

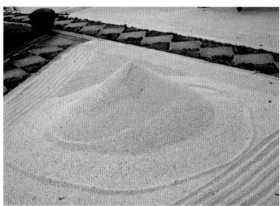

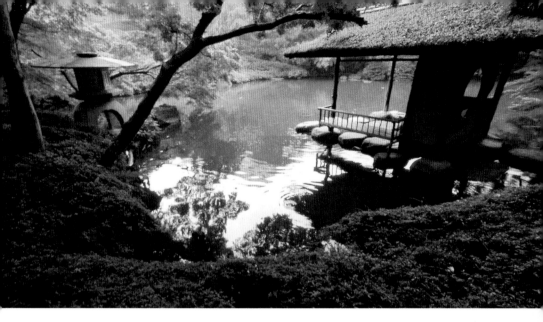

Some of the most intriguing Japanese gardens are those predominantly without growing things, in particular the Zen-inspired dry *karesansui* gardens, "mountains and waters without water," that are simply and sparely styled from rocks, pebbles or raked sand to represent rivers or seas.

Some "well-dressed" gardens can have their own accessories. *Ishidoro* are stone lanterns that light the pathways of stroll gardens after dark.

The flickering candles cast a delightful play of light and shadow as they enhance enjoyment of the scene. In temple gardens, such lanterns had often been given as votive offerings.

Stone is also utilized as the practical and appealing natural material for *chozubachi* or water basins. The jewel-like water ripples gently with a breeze and reflects the sky above and surrounding trees to multiply the joy of nature.

Above A pavilion at the edge of the pond at Happo-en Garden in Tokyo's Shirokanedai.

Below Stepping stones cross a corner of a pond at Tokyo's Kiyosumi Teien.

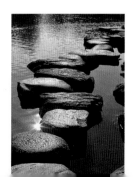

Left A stone *chozubachi* water basin and bamboo ladle accessorize a garden in Kyoto.

Below A cherry tree in full bloom adds to the grace of the "Full Moon Bridge" at Ritsurin Koen park in Takamatsu, Shikoku.

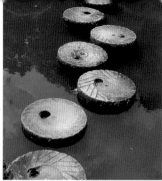

Left A footpath styled from old millstones once used for grinding buckwheat (*soba*) crosses the pond at Isui-en in Nara.

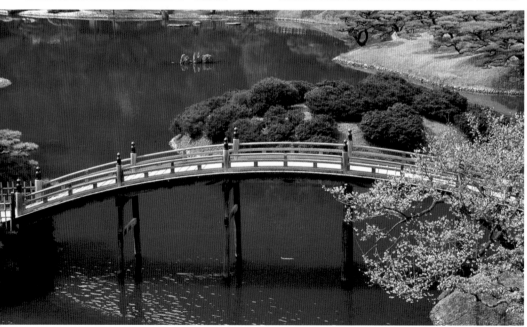

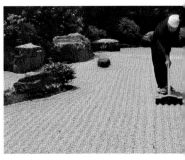

Left A zigzag *yatsuhashi* boardwalk over iris beds at Koraku-en in Okayama.

Right A monk rakes the dry landscape garden at Myoman-ji Temple in Kyoto.

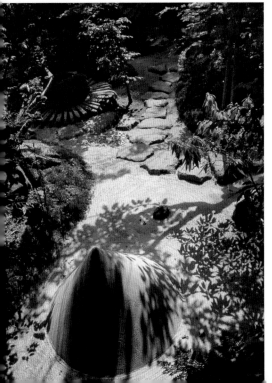

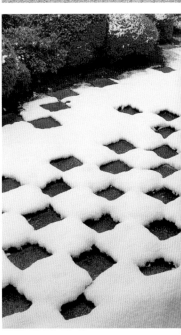

Left Leafy shadows dapple the Kyoto temple garden at Hoso-in.

Right Snow carpets the Abbot's Hall garden in Tofuku-ji Temple in Kyoto.

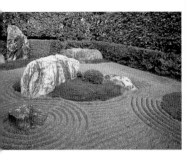

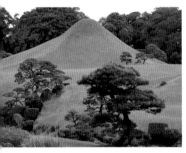

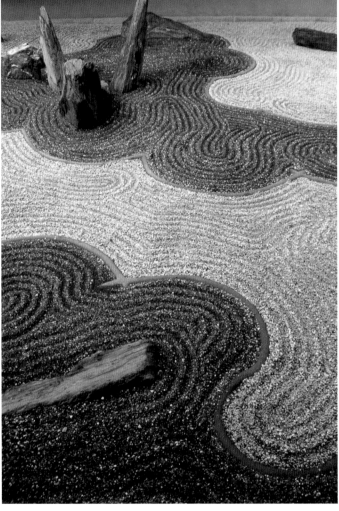

Top Exceptional rocks are set on a ground of raked gray gravel at a subtemple garden within Kyoto's Myoshin-ji complex.

Above A grass covered recreation of Mount Fuji punctuates Kumamoto's stroll garden Suizen-ji Joju-en on the island of Kyushu.

Right The "Dragon in the Clouds" garden by Mirei Shigemori at the Ryogin-an Temple in Kyoto.

Opposite below One of Japan's best-known dry landscape gardens belongs to Kyoto's Ryoan-ji Temple.

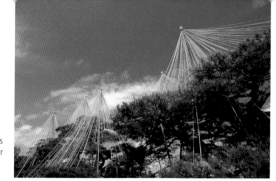

Right Traditional straw rope snow guards (*yukizuri*) are suspended above pine trees at Kanazawa's famous Kenroku-en garden.

Far right Lush greenery surrounds a *chozubachi* water basin at Kyoto's Sanzen-in Temple.

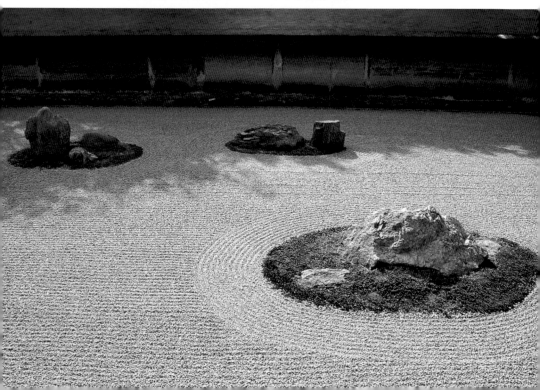

geishas
and maikos

The word *geisha* means "art person." It is little known that the original *geisha* were men. *Geisha* are highly trained and skilled in the traditional arts of entertainment—lighthearted games, playing musical instruments (particularly the three-stringed *shamisen*) and traditional Japanese dancing—while wittily conversing and graciously serving food and drinks. It is a career in which they are able to work to quite an advanced age. In the distant past, girls sometimes began their training very young, at age ten or so, but today's mandatory education laws mean that girls must complete middle school and so are unable to begin such intensive training until about fifteen. These days, when greater choices are available for women, being a *geisha* is not such a popular career.

Geisha dress splendidly in the most gorgeous *kimono* and *obi*

Left During Hassaku, *a geisha* dressed in a formal black *kimono* and hair ornament suitable to the month of August, pays respect to her teachers.

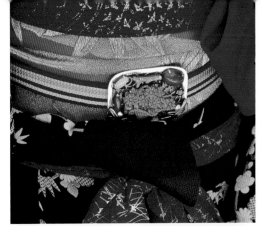

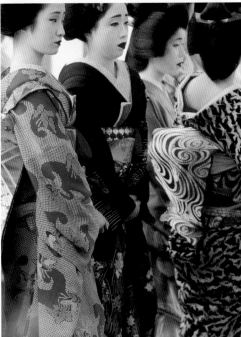

Left above This *geisha* wears a silver, coral and gemstone sash clasp (*obidome*) for a festive occasion.

Left below A group of *geisha* attend an outdoor tea ceremony.

Below The napes of *maiko* are traditionally accented with a design in white makeup.

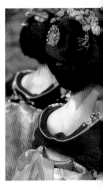

29

sashes, making their appearance like party confections, adding to the extraordinary overall artistic effect.

Geisha, or *geiko* in the local Kyoto dialect, and their *maiko* apprentices, are symbols of that city, which was an ancient capital of Japan where traditions are still strongly upheld.

Geisha and *maiko* live together, sorority style, with a *mama-san* in charge in a house called an *okiya*. They are hired to accompany and entertain clients at parties in certain teahouses and restaurants. Their company is quite costly, and is calculated "per stick," as traditionally a certain sum is charged for each period of time needed for a stick of incense to burn down, roughly ten minutes.

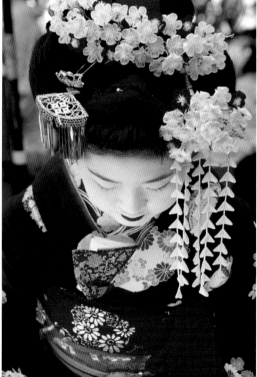

Above A *maiko* pays a New Year visit to a teahouse or *o-chaya*.

Right A bedecked *maiko* busies herself serving ceremonial tea at Kitano Tenmangu Shrine in Kyoto during the plum blossom festival.

Center right *Maiko* place dedicatory chrysanthemum flowers in memory of a renowned Kyoto poet during the Kanikakuni Sai festival.

Right A *maiko* passes through the architecturally preserved Gion Shimbashi, an area with numerous traditional restaurants and teahouses.

Below White face makeup and scarlet lips are the hallmarks of a *maiko*.

Bottom The hair ornament (*kanzashi*) of a *maiko* in seasonal autumn colors.

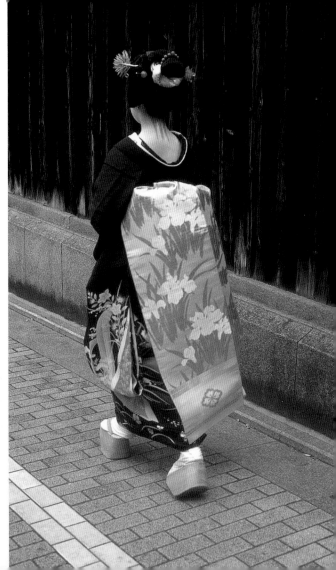

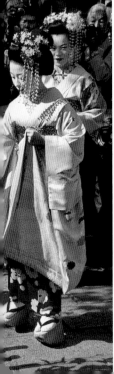

koi

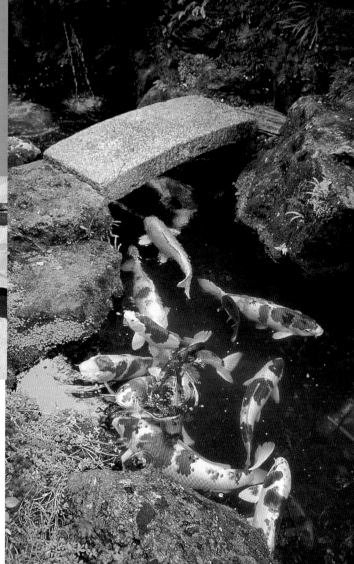

Above A lone orange *koi* skirts the rock slabs in the pond of Tokyo's New Otani Hotel garden.

Right A *koi* pond beautifies a Kyoto teashop garden.

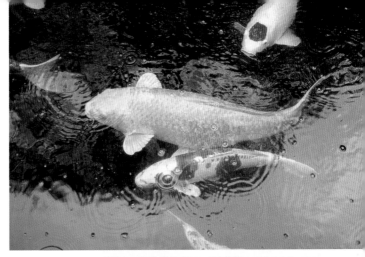

Nishikigoi or brocaded carp, better known as *koi*, are ornamental domesticated carp selectively bred from dull gray Eurasian wild carp species for their colors and patterns and type of scalation. They are popular inhabitants of garden ponds, admired for their beauty, graceful movements and longevity, while requiring little care. They have very acute senses of hearing and smell and zoom-like eyes. They also possess a submarine-like ability to maneuver in water.

Koi are symbols of strength and perseverance, and because they are able to swim against streams and even up waterfalls are often called "warrior fish." Thus, the carp is symbolic for Boy's Day, depicted in the form as *koi nobori*, streamers that fly in the wind, in the hope that one's sons will grow up with courage and strength.

Collectors call *koi* "living jewels" for their variety of vivid colors from tiny sacs of pigments and crystals in their skin cells. They are aesthetically ranked based on their beauty of color and pattern, and can be very costly. They are collected by wealthy enthusiasts who enjoy participating in *koi* competitions.

Above The *koi* at the back with the *tancho kohaku* (red-crested crane/rising sun flag) marking is the obvious star of this collection.

Right A cluster of *koi* display the whole range of typical colors and markings.

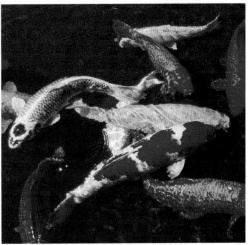

otaku culture

Right A child entertains himself in a room of the Toei Animation Gallery in Tokyo.

Otaku, in modern Japanese slang equivalent to a "geek" but more generally an obsessive fan of some form of entertainment, hobby or topic, is part of the new pop culture sweeping Japan—even the world. Originating centuries ago in Japan in the form of humorous, random, anthropomorphized animal sketches and developed further during the later woodblock print (*ukiyo-e*) boom, this new culture, rather than being directed from "above," as with most other aspects of culture, is directed from "below." It ranges from an interest in comics (*manga*), TV and film animation, collecting plastic figures from those worlds and killing time in *manga* cafes, to the surprising concepts of costume play (*cosplay*), maid (*meido*) cafes and karaoke rooms. It is basically a search by the lonely for self-identity, with fantasies of their own, fired by a variety of consumer goods and mascot memorabilia. In these ways, the mind escapes from the stresses

Below Character dolls of all sizes, and posters are popular goods in shops all around Akihabara.

Below left Maids (*meido*) practice serving in a "maid cafe" in Ikebukuro.

Bottom Stacks of newly released *manga* comics await buyers in Ikebukuro's Animate store.

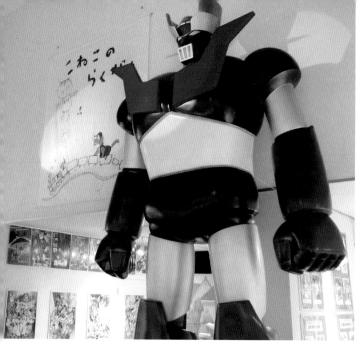

of modern life, particularly by those who lack social skills or are seemingly socially unfit. All this is supported by conventions, summits and festivals held worldwide.

Many popular characters are drawn from Japan's rich stock of figures from history and religion, who in this modern way are educating and passing on their wisdom about life.

One of the important creators is thought of as "the god of manga." Hundreds of museums, galleries and theme parks have arisen nationwide, triggering melancholic and nostalgic history through *anime* tourism guides and "pilgrimage" maps to the actual sites portrayed in the stories, known as "sacred places" or spiritual "power spots."

Above A huge Gundam figure is displayed at the Anime Gallery.

Right A boy chooses a toy from a vending machine in an Akihabara shop.

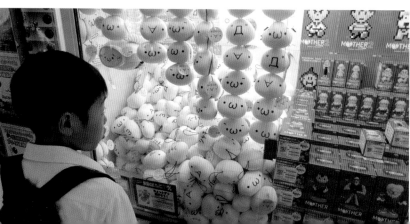

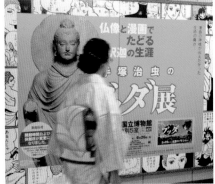

Left A woman studies a museum poster advertising a major exhibition about Buddha, with antiquities, which includes a popular *manga* about Buddha's life.

Above Kyoto's Manga Museum has a research library of publications organized by year.

Right Animate is a famous *anime* store in Higashi Ikebukuro.

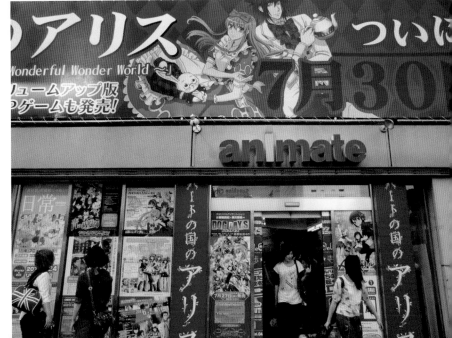

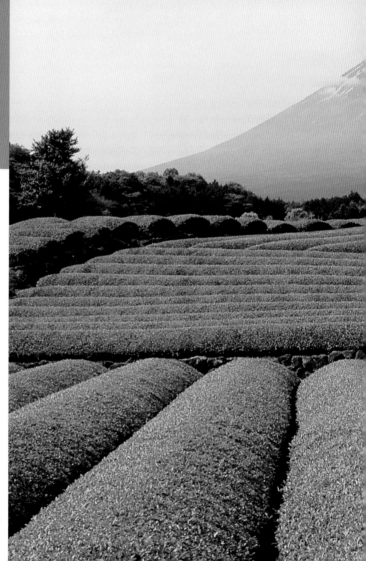

mount fuji

Majestic Mount Fuji, a dormant volcano for three centuries, stands at 3,776 meters and is visible from hundreds of kilometers away. Its name translates as "unique mountain," "an authority" or "immortality."

Popularly called Fujiyama by foreigners but by the Japanese always a respectful Fuji-san, "the most venerable of all," Mount Fuji is a symbol of the nation. With its ideal cone shape and the inner forces of a volcano, it creates magical looking clouds and diamond-like sun shapes around its crater. Long beloved by artists, its ever-changing daily

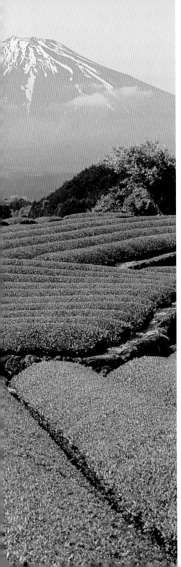

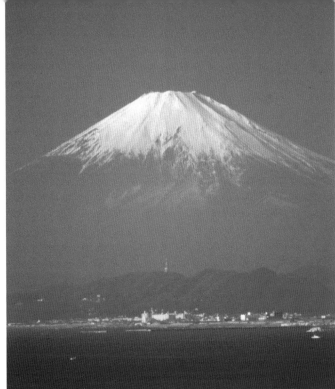

Left Expansive tea fields against their impressive backdrop in Shizuoka.

Above The iconic mountain seen from the shore near Kamakura.

appearances also make it a magnet for passionate photographers.

The pilgrimage to worship the mountain goddess or, nowadays, secular climbing, attracts some 200,000 climbers in the short climbing season each summer.

Below Carp streamers (*koi nobori*) decorate the landscape for Boy's Day.

Right An illustration in an *anime* museum pavilion at Fujikyu Highlands.

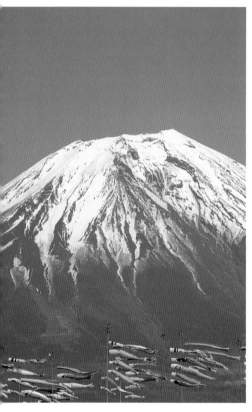

Right A painting on the façade of a hot spring in Yamagata's Gin-zan Gorge.

Right An aerial view of Mount Fuji dappled with summer clouds.

Below A summer view of the Fujikyu Highlands area.

Below right Barrels of *saké* donated to Tokyo's Meiji Shrine feature the iconic mountain.

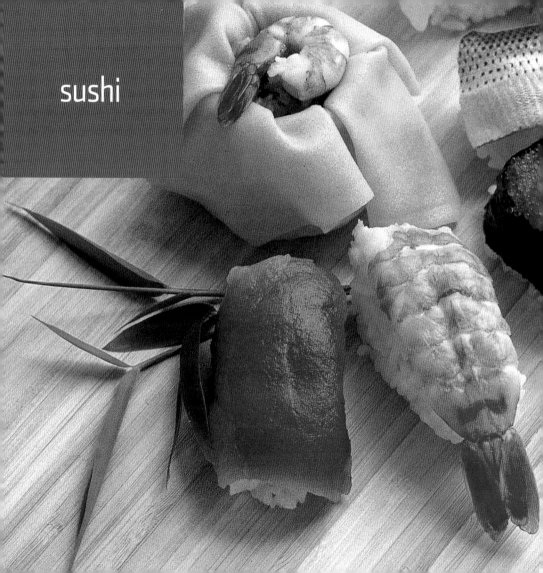

sushi

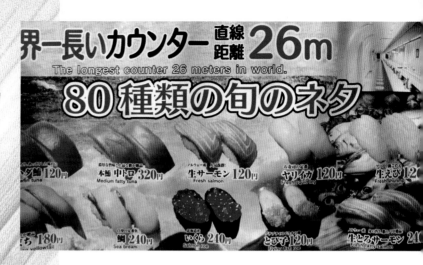

界一長いカウンター 直線距離 26m

The longest counter 26 meters in world.

80種類の旬のネタ

本鮪 中トロ 320円 Medium fatty tuna

生サーモン 120円 Fresh salmon

ヤリイカ 120円 Fresh squid leg

生えび 120円 Fresh shurimp

〆タ節 120円 wfin tuna

鯛 240円 Sea bream

いくら 240円 Salmon roe

とび子 120円 Flying fish roe

生とろサーモン 240円 Fresh fatty salmon

yellowfail

Sushi consists of a lightly vinegared ball of rice seasoned with *wasabi* horseradish and topped with raw seafood or, occasionally, a vegetable such as onion sprouts (*me-negi*) or the recently trendy pickle *sushi* or even some California avocado.

The classic hand-formed shape originated in the Edo era (1603–1868) and is now called Edo-mae-zushi ("In-front-of-Edo sushi") after the sea waters at the edge of the city. Making this *sushi* requires a great deal of training and skill. It is therefore usually not prepared at home where other variations might

Opposite An assortment of seafood *sushi* served on a bamboo board.

Above An advertisement for *kaiten-zushi* or conveyor belt *sushi*, on what is claimed to be the longest belt (26 meters) in the world, in a Nara *sushi* bar.

be made, such as rolled *sushi* (*maki-zushi*) or cones of seaweed wrapped around selected filling ingredients (*temaki-zushi*) by family members at the table.

Going to a *sushi* bar is a large part of the pleasure of this food. It is marvelous to watch the skilled

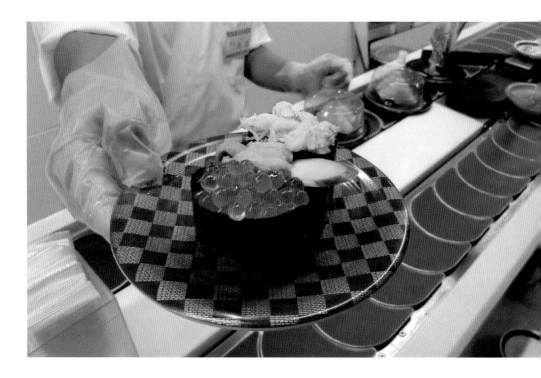

sushiya-san wield his knives and shape the *sushi*, as he (and it usually is a he) banters with his customers. For classic *sushi*, home delivery is very practical. Almost every family keeps a phone number for their favorite *sushi* bar handy for such occasions when they feel like eating *sushi* or when they need to feed visitors.

Kaiten-zushi, literally "conveyor belt *sushi*," has become very popular because it is a fun way to eat and is very reasonably priced. There is even one place where the conveyor belt *sushi* is made by a robot!

Far left Plates of *sushi* are placed on the longest *sushi* bar conveyor belt in the world.

Left *Sushi* rolls with assorted fillings.

Below, left to right *Hotate*; *ebi*; *maguro*; *ikura*, *kani*, *uni*.

tattoos

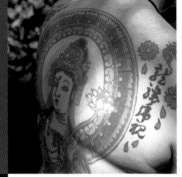

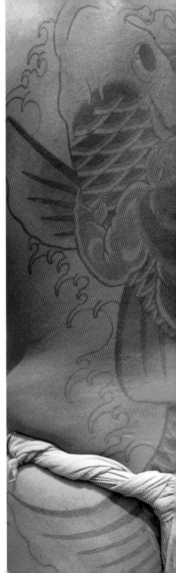

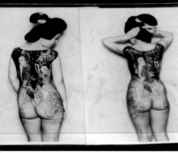

Top A female festival participant has an image of Kannon-sama, the Buddhist deity of mercy, tattooed on her back.

Above Old photos of tattooed *geisha* displayed at the Tattoo Museum in Yokohama.

Right A participant at a Tokyo Bay summer festival shows off his *koi* tattoo, created in the hope that he will have the reputed vigor and strength of a *koi*.

Historically in Japan, criminals were identified by tattoos, a practice mentioned in the *Nihon Shoki* (Chronicles of Japan), the second oldest history. Tattooing or *irezumi* is derived from *sumi*, the charcoal inserted beneath the skin to create the basic dark blue coloration. It is also called *horimono*, engraving on the skin with the insertion of colored pigments. During the Edo era (1603–1868), it became a popular body ornamentation, especially among scantily-clad laborers. Later, it was favored by gang members.

Polite Japanese society does not find tattoos acceptable and people with them are often avoided and are barred from public baths, pools and sports clubs. Traditional tattoos can, however, be seen at summer festivals on some *mikoshi* shrine bearers.

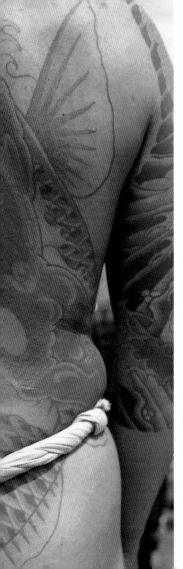

In Japan, one can speak of artistic tattooing, for nowhere are found such splendid designs, either taken from mythology and religion for talismanic effect to wish for various powers that such designs suggest, or simply for fashion's sake among youth. The artist is called *horishi*.

The Meiji era (1868–1912) saw numerous foreigners enter the country and the government, not wanting to be thought "backward," banned tattooing among its citizens. The practice continued somewhat under cover. As foreigners were permitted to be tattooed, England's future King George V and Tsar Nicholas of Russia are both said to have been tattooed as young men when they visited Japan. Up to today, Yokohama has well-known tattoo studios and a tattoo museum owned by the prize-winning artist Horiyoshi III.

Below Peony flowers and other assorted motifs decorate the chest of a festival celebrant.

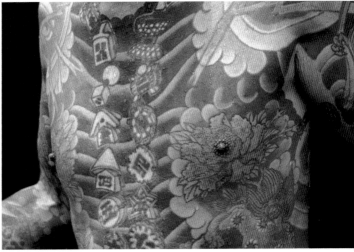

trains

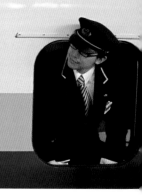

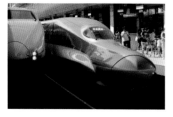

From quaint streetcars, one line of which still operates in Tokyo, to the developing levitation trains of the future, specially designed for safety during earthquakes, the Japanese have proven themselves to be masters of train transport.

Japan's first train connected Yokohama to Tokyo in 1872. The first subway ran in 1927, and the extensive Metro system today carries millions of passengers each day. The high-speed, long-distance Shinkansen, popularly called the "bullet train," was launched in 1964 in time for the Tokyo Olympics. It is now possible to travel on a bullet train the length of the country, from Aomori in the north to Kagoshima in the south. Watches can be set by the punctuality of the trains.

The most recent service feature of Japan's trains is of "women only" cars, which are offered for the comfort and peace of mind of female passengers.

Top A last-minute boarding check on "Max," the Tohoku-bound Shinkansen (bullet train).

Above Hayabusa, the latest and fastest bullet train, stands at Tokyo Station.

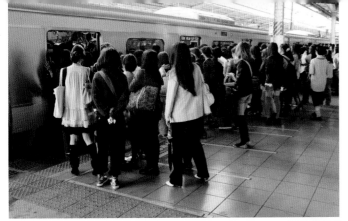

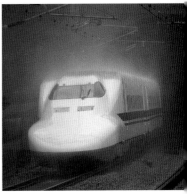

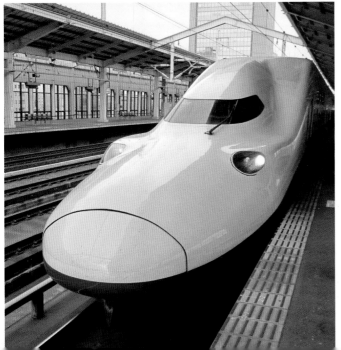

Above left Morning boarding of the "women only" car at Tokyo's Chuo Line.

Left A "bullet train" waits at a station for passengers to board.

Above The Tokaido bullet train emerges from a tunnel into heavy rainfall.

Below A local Hakone sightseeing train full of sleepy elementary schoolgirls.

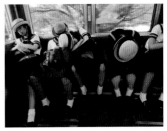

tea

Above A woman clad in a *kimono* serves *macha* tea on a festival occasion.

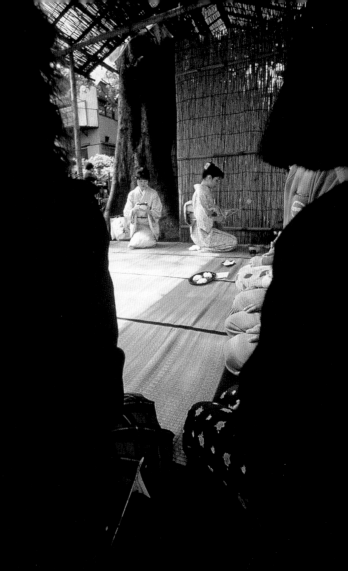

Tea (*cha*) is the great beverage of Asia. Green tea is much favored by the Japanese, and this *cha* is always prefixed with the honorific *o*. *O-cha* is steeped and drunk many times a day at home and in offices, and is also widely available bottled, even from vending machines.

The drinking of *o-cha* has many health benefits, including anti-bacterial, anti-viral and anti-hypertensive action. It is also said to relieve fatigue and sleepiness, which was the reason that it was first introduced to Japan by Zen monks as an aid to meditation. During the Nara period (710–94), monks visiting China brought back tea seeds. Tea is cultivated in various mild-climate regions of the country, foremost among them Shizuoka Prefecture, south of Tokyo.

In the sixteenth century, Sen-no Rikyu developed a ceremonial way of serving *macha*, a tea prepared from powdered tea leaves, and today there are four major tea ceremony schools in Japan led by his descendants. Most Japanese women study the art of tea as part of their "proper" upbringing, a sort of spiritual training to learn grace and patience.

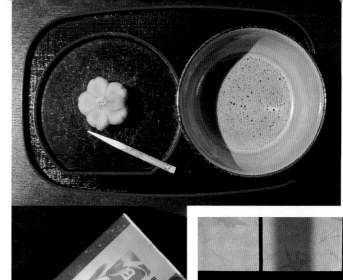

Top *Macha* and a *wagashi* sweet are served at a temple reception.

Opposite right An open-air (*nodate*) tea ceremony is performed at Nezu Shrine's Spring Festival.

Above A package of new tea (*shin cha*), which is occasionally sold at Tokyo's Meiji Shrine.

Right A tea kettle is silhouetted against a *shoji* screen in a private home.

The tea ceremony is referred to as *cha-no yu* ("tea's hot water") or *cha-do/sa-do* ("the way of tea"). Following grand master Rikyu's philosophy, an atmosphere of *wabi* (simple rusticity) is cultivated in both the surroundings and objects used. In an atmosphere of modesty and friendship, tea is prepared in the company of the invited guests.

On many national holidays, tea ceremony associations prepare and serve tea to visitors on outdoor stages at certain temples and shrines, usually in the cooler spring and autumn seasons. In Kyoto, *geisha* and *maiko* likewise perform the tea ceremony to mark special events, particularly during the plum and cherry blossom seasons.

Below left *Macha tate*, the whisking of ceremonial tea.

Below center Teapots filled with *o-cha*.

Below right A tea ceremony performed by priests at a Kyoto temple.

Right Tea beds and a picking basket.

Center right Mountain tea (*yama cha*) for sale, on occasion, at Tokyo's Meiji Shrine.

Far right Meiji tea packages for sale at a shop near Meiji Shrine.

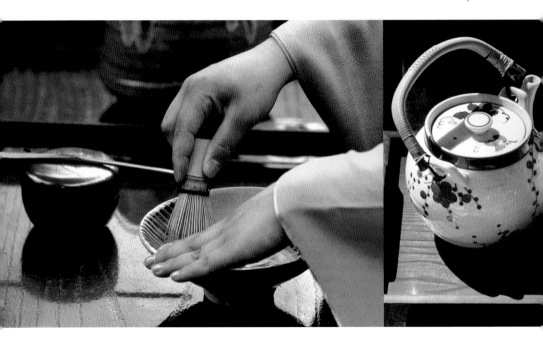

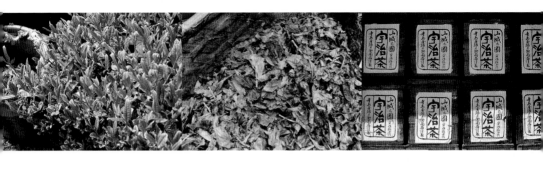

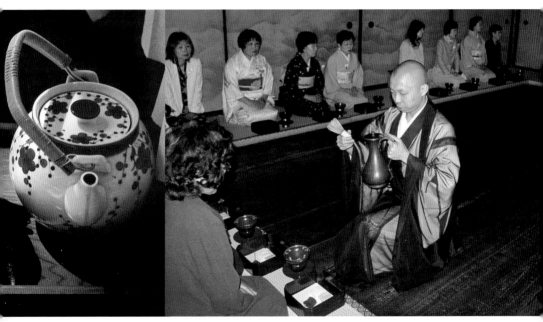

TRADITIONS

The Japanese way of life features many long-respected customs, activities and way of dressing. Due to the plethora of other choices modern life now offers, and the desire for more convenience, some of these traditions are disappearing, although some Japanese who value culture still do their best to maintain them.

Modern and traditional often walk side by side, either separately or in a stylish fusion. Graphic and fashion designers go to great lengths to attract the young with traditional patterns and materials. Workshops for traditional crafts are popular. There is also a newfound enjoyment in mixing the antique with modern as a "cool" way of life.

Buddhist priests at Narita's Shinsho-ji Temple assemble for a ceremonial event.

55

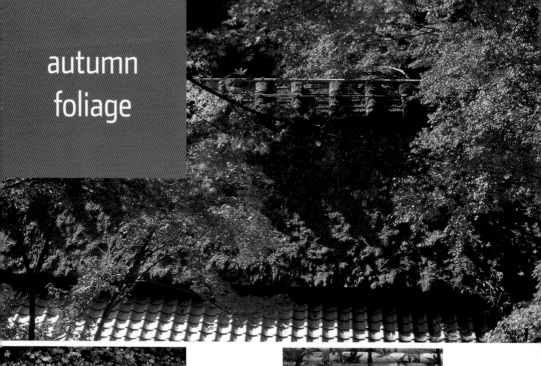

autumn foliage

Above The straw roof of an old *minka* farmhouse peeks through the autumn leaves in northern Kyoto.

Left Fallen maple leaves float in a pond.

Left Fallen autumn leaves on the bamboo lid of a well.

Opposite The Buddhist temple Shinnyo-in is a popular spot each autumn for maple leaf viewing.

As autumn deepens in Japan, bringing with it agreeable cooler temperatures, nature begins its showy transformation. *Koyo*, the profusion of autumn colors, can be relished in many notable places across most of this mountainous country, but perhaps nowhere more so than in much-loved Kyoto and Nara. These cities and their surrounding mountains and hillsides abound with maple trees, commonly called *momiji* in Japanese, and every November they come wildly ablaze. Even the leaves of cherry trees take on reddish tints in autumn. The beautifully shaped leaf of the gingko tree (*icho*) is Tokyo's official symbol. Those trees line many of the city streets, and in autumn the leaves turn a brilliant yellow.

Seasons do not pass unobserved in Japan, but are widely appreciated and celebrated.

During what is, arguably, Japan's best tourist season, visitors flock to the country for park and forest outings and to make the rounds of magnificent temples and gardens. The brilliant foliage and even the fallen leaves are a splendid foil for the age-old sacred architecture with its graceful windows, tile roofs, garden stones and water basins. Maple leaves have been an appealing decorative motif in art,

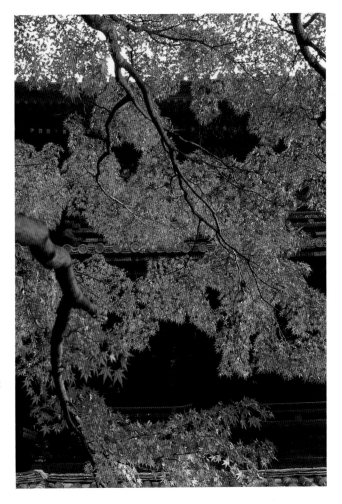

literature and textiles, and a beloved theme in Japanese poetry for more than a millennium.

In this inviting season, certain gardens remain open late for illuminated evening viewing, a time-honored seasonal pleasure of Kyoto life. Some temples open their inner chambers to display rarely seen art treasures to the public. Festivals harking back to the Heian era (794–1185), such as Momiji Matsuri, the Maple Festival, and Kyokosui-no En, a poetry gathering, celebrate autumn as the nobility once did, in magnificent period garments and to the accompaniment of court music and dance. Traditional restaurants offer special seasonal meals during this time. Should unseasonal weather change the expected dates of *koyo*, the highly organized tourism industry can be thrown into complete disarray.

Right A soft rain adds a pensive mood to the autumn scene.

Far right Maples appear in shades from soft to brilliant and bring nature's year to a spectacular finish.

Far left Leaves float in a stone *chozubachi* water basin at Sanzen-in Temple, Kyoto.

Left Ornamental woodwork of the study hall at Kyoto's Kozan-ji Temple is set off by the autumn foliage.

Right Autumn colors at the Shinyo-do Temple in Kyoto attract many sightseers in November.

calligraphy

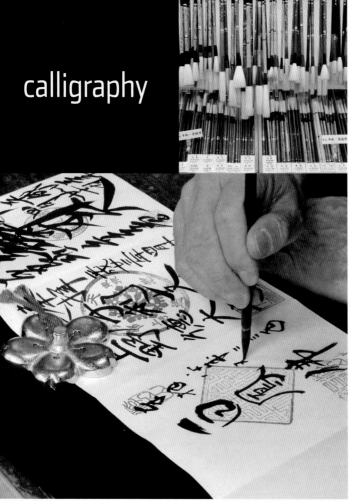

The word calligraphy in English derives from the Greek *kalligraphia* meaning "beautiful writing." The art of beautiful writing in Japanese is called *shodo* ("the Way of Writing") and is carried out with a brush and black *sumi* ink.

Japanese writing basically consists of ideographs adopted from China in about the fifth century. From first writing in the Chinese language, the Japanese then adapted the Chinese characters, called *kanji*, to words in their own language, giving them their own pronunciations. They also developed a phonetic syllabary called *kana*.

Brush writing is traditionally taught in school and sometimes further pursued with private instructors. Excellent calligraphy is esteemed and can be collected as valuable fine art.

Above left A selection of brushes for sale at a calligraphy exhibition.

Left A priest inscribes and stamps a pilgrim's inscription booklet.

Right The first calligraphy of the New Year, by elementary school students, is displayed beneath the eaves of Tokyo's Meiji Shrine.

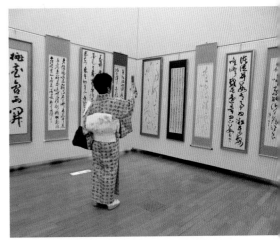

Left The character for the word *kami* (deity) is among the calligraphics at a Tokyo exhibition.

Right A viewer enjoys the annual exhibit of calligraphy at Roppongi's National Art Center.

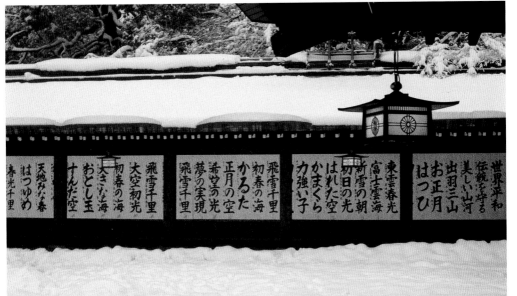

curtains

Cotton curtains called *noren*, bearing a company name or logo, are often hung over shop doorways to keep out the sun and the dust of the street. They are split into panels at intervals for customers' ease of passage.

Noren are often seen hanging at the front of restaurants to signify when they are open for business, then moved back inside when they close. Within private homes, *noren* sometimes provide a traditional and decorative touch when used to partition space or to provide some privacy.

Dark blue dying with white lettering seems to be one of the

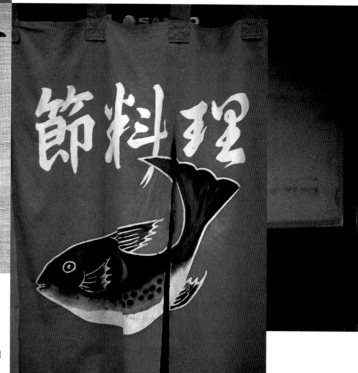

most popular combinations, and sometimes real but costlier indigo color can be seen.

Another popular type of *noren* is made of twisted straw rope. Called *nawa-noren*, they often mark the entrance to a cheap drinking establishment (*nomiya*), accompanied by a red lantern.

Below far left A bell (*suzu*) decorates the curtain of a well-known Kyoto pickle shop.

Below left A fish motif on the *noren* of a restaurant signals their specialty, seasonal dishes.

Right This restaurant specializes in tuna (*maguro*) dishes.

Below A plum blossom design decorates the entrance curtain of an exclusive *ryotei* restaurant with a surrounding garden.

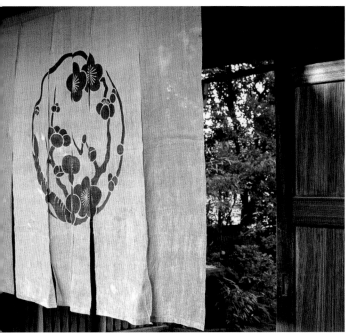

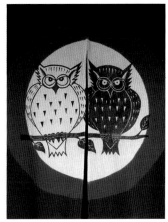

Above A popular owl motif makes an inviting entrance to a Kyoto souvenir shop.

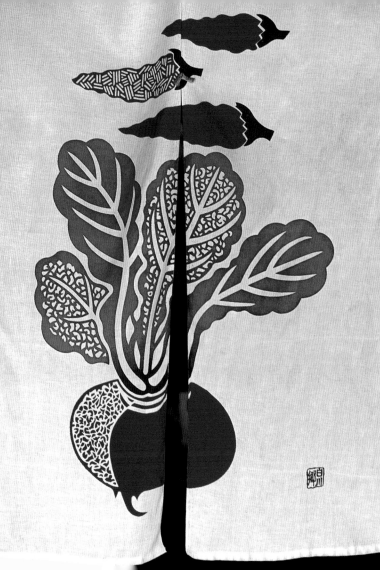

Above A bright curtain welcomes customers to a countryside eatery.

Left A vegetable design decorates the entryway to a Kyoto pickle shop.

Right A bamboo design on an indigo curtain marks a traditional clothing store in Tokyo's Asakusa "downtown" district.

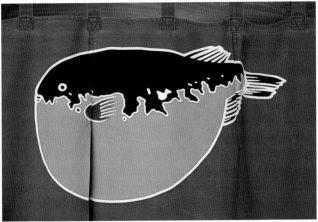

Top A bold blowfish (*fugu*) adorns the *noren* of a *fugu* restaurant.

Above A casual pub-cum-cafe (*izakaya*) has a *nawa-noren* hanging at its entrance.

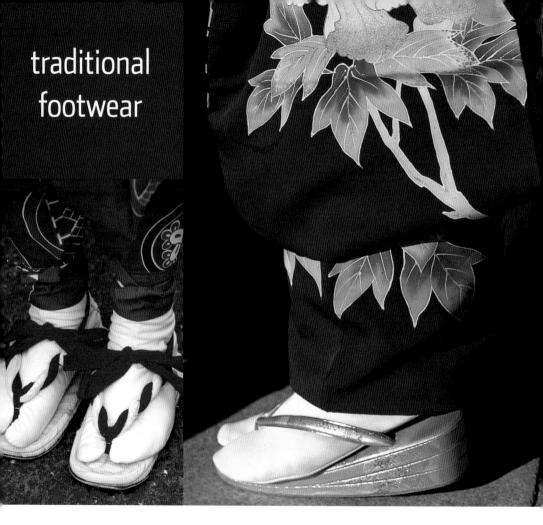

traditional footwear

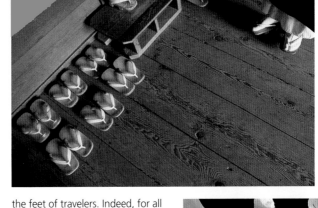

Far left Leather-soled straw *setta* are fitted with festival thongs and ties to make for a sure step.

Left Leather *zori* are the proper accompaniment to an elegant *kimono*.

Right Wooden *geta*, removed by priests and monks, line the entrance to a temple's prayer hall.

Right below Straw footwear, fit for snow, worn at a winter festival in the north of Japan.

There are moments when the present and even the future walk side by side with the past. When traditional footwear is worn, it is not necessarily for the sake of nostalgia but because it still suits elements of today's way of life, including Japan's distinctive ceremonies and festive occasions.

According to the third-century Chinese chronicle *Wei Zhi*, the Japanese of that time went barefoot. The earliest forms of footwear—primitive twisted and tied straw *waraji*, flat thronged *zori* sandals and wooden clog-like *geta*—are still worn today, seventeen centuries later. In earlier times, when the comfort of wheeled transport was restricted, straw *waraji* provided necessary protection for the feet of travelers. Indeed, for all but the mightiest, who were borne aloft in palanquins, even the most grueling journeys were undertaken on foot. The rough straw of the *waraji* grips the earth. The shoes still make good farm footwear for some country folk. Participants at Shinto festivals don *waraji* to joyfully—and sure-footedly—carry the sacred *mikoshi*, the portable shrine which is a temporary festival home to the honored god, through the neighborhood streets.

Traditional Japanese footwear can make the wearer slow and humble or fast and brave. Women bound in their silk *kimono* and *obi*, wearing white, split-toed *tabi* socks and thonged *zori* shoes, mince along on their way to a tea ceremony.

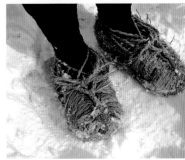

The click-clack of wooden *geta* was once a distinctive sound of Japanese summer. These double-toothed clogs lifted their wearer above the rainy season's wet pathways and kept the feet airy and dry in the steamy heat. They used to be *de rigueur* with the cotton *yukata* wrap, but today they are seen (and

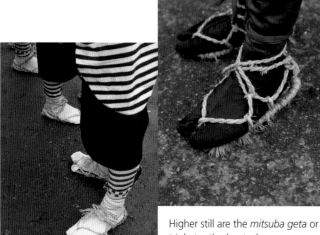

Far left Straw sandals (*waraji*) are typical festival footwear.

Left Twisted rice straw has long been used to fashion traditional footwear.

Below A monk in white *tabi* socks dons his straw-soled wooden *geta*.

heard) mostly around hot spring resorts or at summer festivals. Buddhist priests wear them with their robes and, occasionally, a young man with sartorial flair handsomely pairs his *geta* with jeans, bringing smiles to the faces of passersby.

High, platform-soled, thronged *pokkuri* can be seen on young girls dressed in festive finery at Shichi-Go-San, the Seven-Five-Three Child Blessing festival, and on Kyoto's apprenctice *geisha*, called *maiko*.

Higher still are the *mitsuba geta* or triple-toothed *geta*, long ago worn by the highest class of Edo-era courtesan.

For the surest foot of all, workers wear *jikatabi*, canvas *tabi* with rubber soles. Colorful examples can be seen these days as modern fashion statements.

Although it has been considered acceptable apparel in Japan since the late nineteenth century, Western footwear has only gained true popularity since the end of World War II. As a result, traditional Japanese footwear becomes less and less visible with each passing year, but for those who learn to cast their eyes soleward, there are still historical footnotes.

The traditions are modernly maintained through imaginative re-creations, such as illustrated *zori* soles or *jikatabi* in new and unexpected colors.

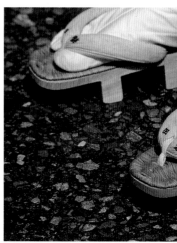

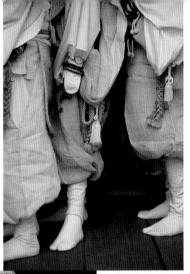

Left Canvas split-toed, rubber-soled *jikatabi* are worn in white by ascetic mountain monks called *yamabushi*, and in indigo or black by laborers.

Below A Shinto priest strides across shrine grounds in his black-lacquered *asagutsu* clog shoes.

Right An itinerant monk wearing straw *waraji*.

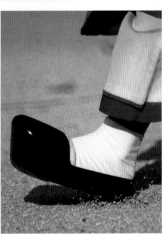

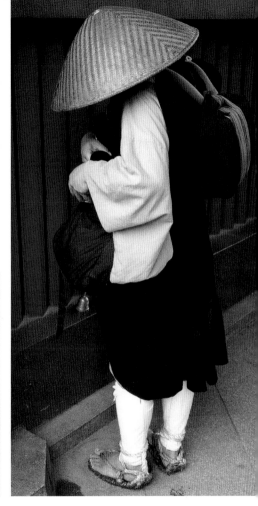

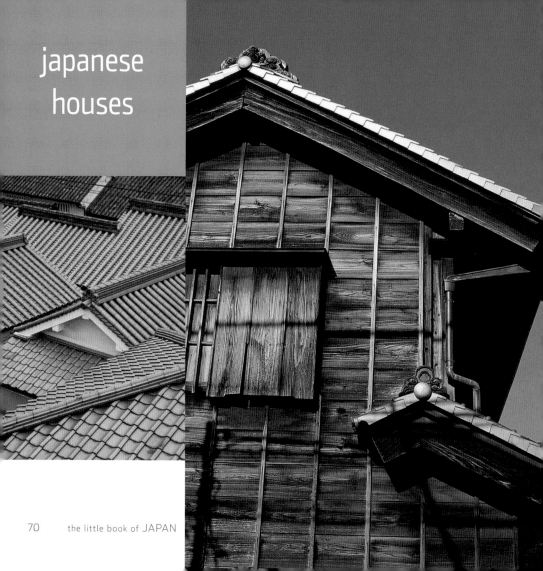

japanese
houses

Traditional Japanese houses are built to accommodate the hot and humid summers. They bring in fresh air, and also the view, which may only be a corner of a diminutive garden.

Flexible interiors maximize the multiple use of space, as well as creative use of natural materials. Opaque paper-covered sliding

Opposite left Gray tile rooftops in Oita, Kyushu.

Opposite right A typical old weather-beaten wooden house of an earlier era, the likes of which can still be seen in small numbers in any city or town.

Right *Futon* air on the balcony of a condominium.

Below A traditional thatched farmhouse (*minka*) still survives in Shirakawa, Gifu Prefecture.

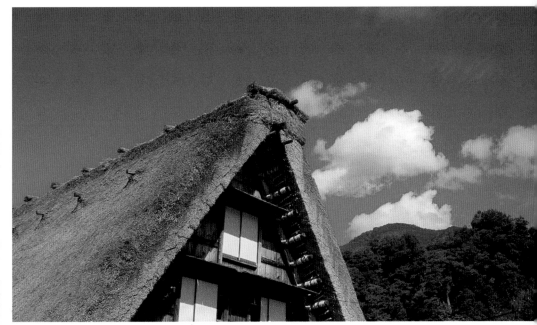

doors (*fusuma*) allow rooms to be closed off from or opened up to join others. Sliding window screens (*shoj*) are often covered with translucent paper, bringing a wonderful quality of light into rooms. Floors may be covered with comfortable and aromatic straw mats (*tatami*), making them pleasant places for sitting and for sleeping on padded cushions or mattresses (*futon*). Even modern apartments typically have at least one room with such traditional *tatami* flooring.

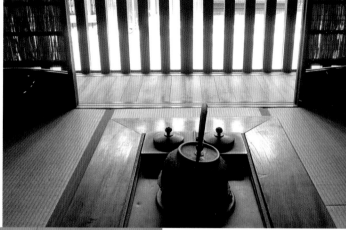

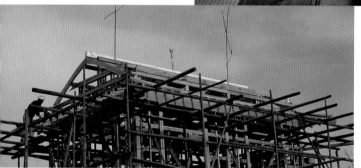

Above The roof-raising stage (*mune*-age) of a house under construction. Mounted above the roof line are the arrows and amulets believed to protect the work.

Top An old Nara merchant house with its traditional sunken *irori* fireplace.

Right The traditional mode of insulation, combining strips of bamboo and mud, is not often seen today.

Far right A combination of stonework and wood, with windows shaded by reed *sudare* screens.

Right The upper story of a Kyoto teahouse features decorative roof tiles and a round window (*yoshino mado*).

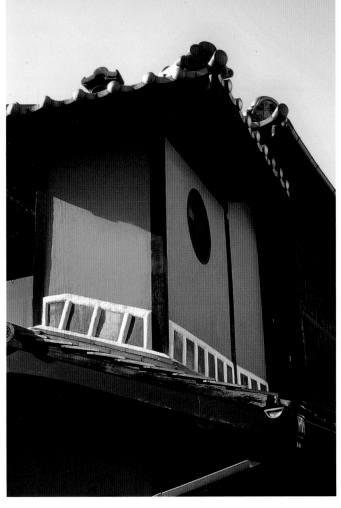

The elegance and openness of traditional housing features remain desirable, but the convenience and stylishness of Western-type kitchens and baths are increasing their popularity.

A single-family detached home is the ideal, but high land prices makes affordability the biggest problem for average families. Multi-unit dwellings are very popular. In fact, more than half of homeowners live in such apartments or condominiums, often at some distance into suburbia.

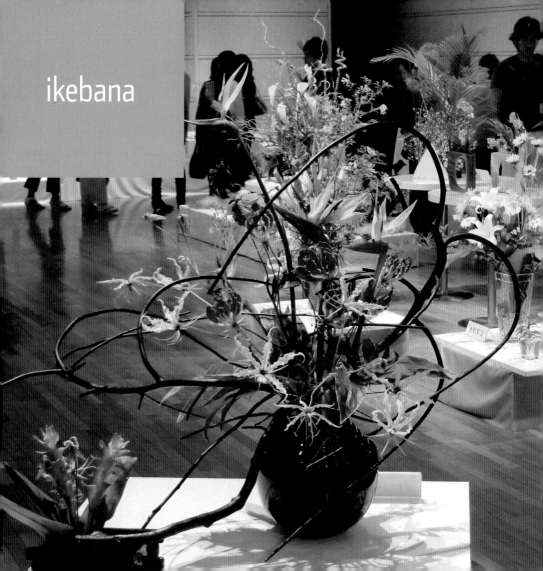

ikebana

Ikebana is known as *kado* or "The Way of Flowers." This method of flower arranging, meaning "living flowers," had its beginnings in Buddhist offering rituals, which were influenced by the *yorishiro* of Shinto, the markers of evergreen that signify the sacred place to which the deity descends to earth. In fourteenth-century Kyoto, it was a popular art form practiced predominantly by men. The shogun Ashikaga Yoshimitsu, of Golden Pavilion renown, held many salon-like gatherings of aristocratic and priestly flower aficionados. These often included *doboshu*, the interior decorators of the day, who set art and flowers around the rooms. Among them was the fifteenth-century Buddhist priest Ikenobo Senkei, who established the oldest school of *ikebana* art, which still carries on today under the leadership of his forty-fifth generation direct descendant.

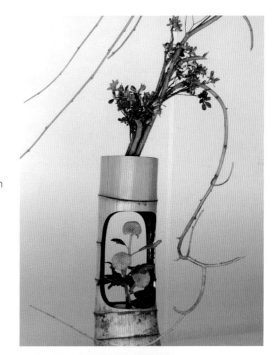

Left A show at Tokyo's Ebisu Garden Place.

Right A woman clad in *kimono* photographs the floral creation by her friend.

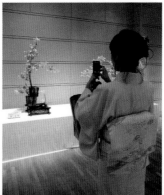

Above A bamboo trunk is popularly used as a vase for casual arrangements.

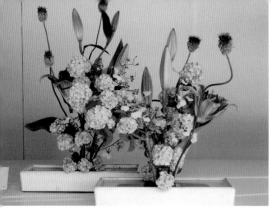

During the Edo era of the next two centuries (1603–1868), the art filtered down to the *samurai* and merchant classes, and eventually to society as a whole. Today, Japan has around 3,000 *ikebana* schools, with some 15 million practitioners. Although originally it was considered a male art, today it is mostly practiced by women.

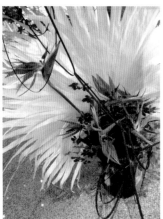

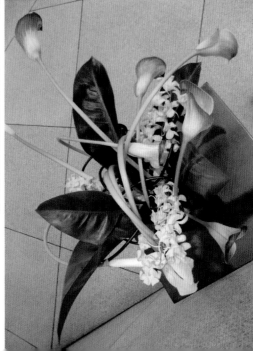

Above left An arrangement of hydrangeas, lilies and poppies.

Far left A fan palm leaf creates a foil for bird of paradise blossoms.

Left A design of highly contrastive elements based on calla lilies.

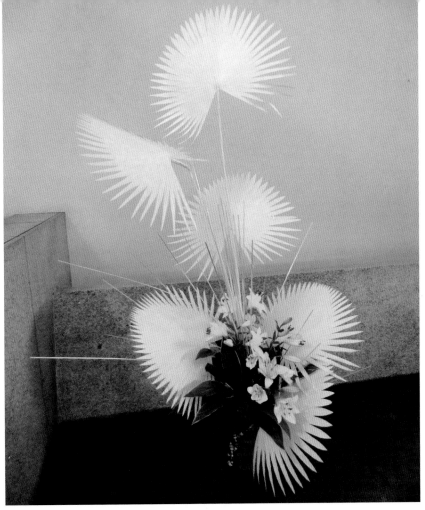

Above Baby's breath creates a soft nest around the stark vertical lines of component leaves.

Left Lilies are arranged with color-treated leaves of the fan palm.

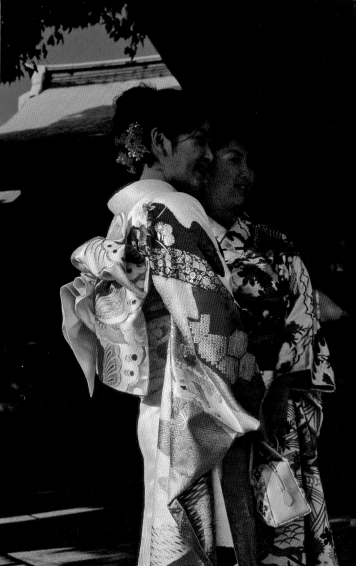

kimonos
and obis

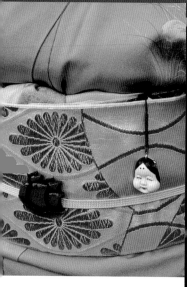

Kimono means literally "thing to wear," thus "clothing." This simple, shapeless garment is, by virtue of the often exquisite textile from which it is hand sewn, one of the world's most beautiful and elegant national costumes, if a bit prim.

Most often the fiber of choice is silk, sometimes wool, and in the heat of summer, cotton or linen. Today, synthetic materials are being increasingly used. The style and colors of the *kimono* vary depending on the age and marital status of the wearer as well as the occasion and the season.

Japanese like to emphasize, especially to foreigners, that the *kimono* is one-size-fits-all. The length can be adjusted by tucking up the excess at the waist. The garment best suits a slim, straight figure. Curves can be suppressed by special undergarments or by filling in "hollows" with purpose-made pads or rolled-up towels. The final desired body shape for the *kimono* wearer is cylindrical.

The *kimono* is being worn less often, partly due to the expense but also the difficulty of putting it on correctly. It is also rather impractical for today's active women.

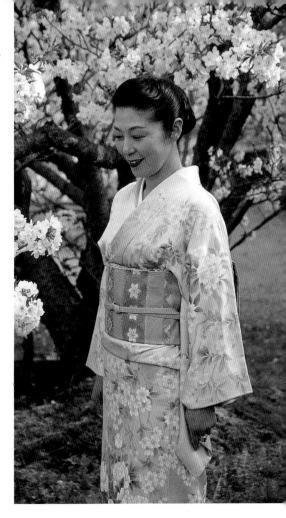

Right A woman, seasonally dressed, poses among the cherry blossoms at Tokyo's Chidorigafuchi.

Far left A sash clasp (*obidome*) in the shape of a boat and a decorative toggle (*netsuke*) with the face of Okame-san, a symbol of good luck and prosperity.

Left A young woman wears a luxurious *kimono* and *obi* sash to celebrate the occasion of her Coming of Age.

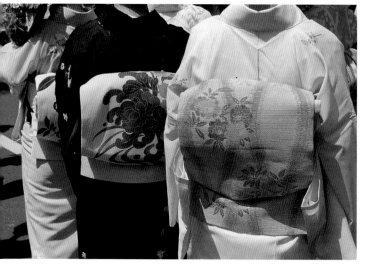

An *obi* is a three or four meter-long sash that has been said to symbolize a woman's heart. Until the fifteenth and sixteenth centuries, the *obi* comprised a simple cord. In the seventeenth century and onward, a wide and very decorative *obi* became fashionable. There are several hundred ways to tie the *obi* into a bow or some other ornamental shape.

As costly as a *kimono* can be (and it truly is a major investment), a fine *obi* sometimes costs as much as three times that price. Some *obi* are true works of art, and are family heirlooms.

Above Here an *obi* is tied into a decorative bow-like shape, one of endless tying styles.

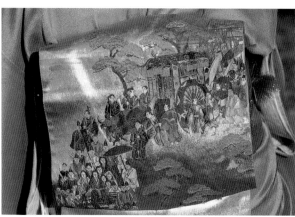

Right This rich golden *obi* is woven with a picture of an imperial procession.

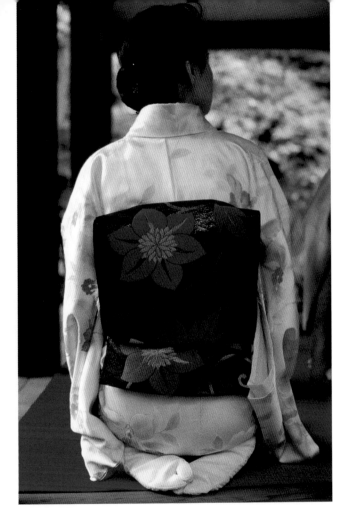

Opposite top Kyoto women attend an Obi Festival, during which a procession of *obi* of the ages is held, among other events.

Left An attendant at an open-air tea ceremony in Kamakura sits in *seiza* position.

Bottom A young woman displays her *furisode* ("swinging sleeves") *kimono* featuring the long, dangling sleeves of the formal *kimono* worn by unmarried women.

A first *kimono* is purchased, or sometimes simply rented, for the autumn occasion of Shichi-Go-San, when children aged seven, five and three are blessed at a Shinto shrine, or for the Coming of Age ceremony, when a young person becomes an adult member of society.

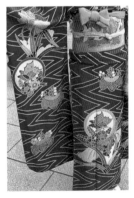

Above *Hiragana* syllabary decorates an *obi* worn over a simply patterned indigo *kimono*.

Right A twenty-year-old dressed for her Coming of Age Day.

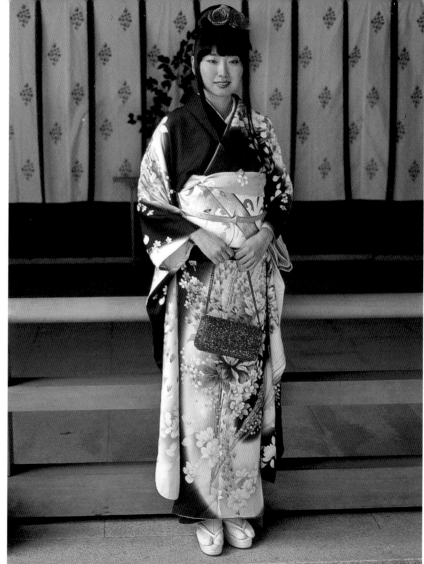

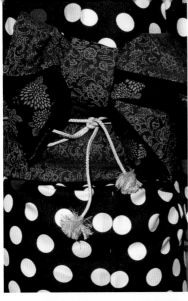

Left A water drop (*mizu tama*) pattern creates a fresh-looking *kimono*.

Right Peacock feathers decorate both *kimono* and *obi*.

Left Autumn grasses are woven into a golden *obi* that accents a chrysanthemum-patterned *kimono*.

Right A phoenix graces a silken *obi* against a background of peacock "eye" feathers.

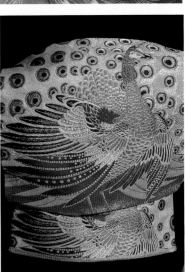

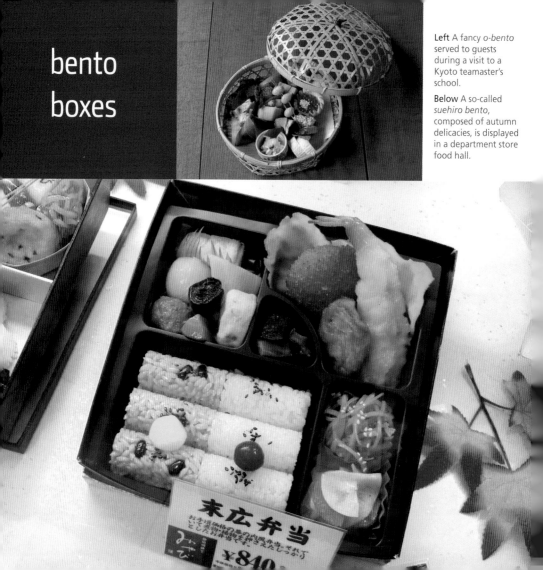

bento
boxes

Left A fancy *o-bento* served to guests during a visit to a Kyoto teamaster's school.

Below A so-called *suehiro bento*, composed of autumn delicacies, is displayed in a department store food hall.

末広弁当

¥840

The Japanese boxed lunch is an art form in itself. The simplest may consist of nothing more than a red pickled plum called *umeboshi* centered on a rectangular field of white rice, looking just like the Japanese flag. This *hinomaru bento* is a bittersweet reminder of past times when poverty allowed no more than an extremely modest yet tasty meal, such as rice and pickles.

The good Japanese wife and mother, even now when many women are employed ouside the home, gets up early so she can prepare nutritious, delicious boxed lunches for her family, filled with many small morsels of various tastes, colors and textures. Children and husbands alike take pleasure

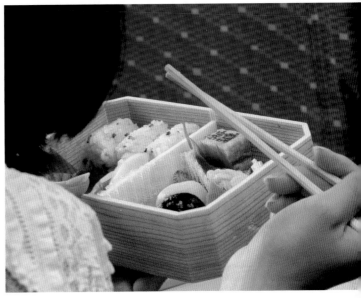

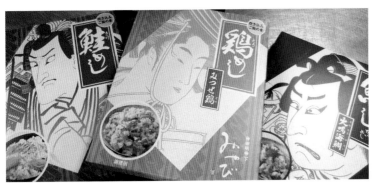

Above A bullet train passenger enjoys an *o-bento* meal during her journey.

Left *Kabuki* characters decorate a variety of popular rice mixture dishes.

Below *Bento* packaging commemorating a steam locomotive, type C61.

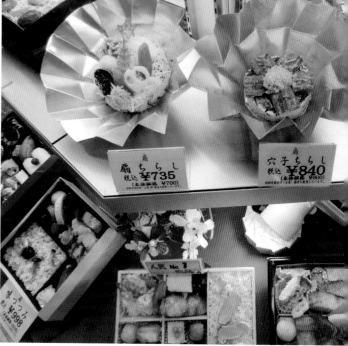

and quiet pride in this typically unspoken expression of love.

Supermarkets and convenience stores sell millions of attractively packed boxed lunches every day. They are available to suit every taste, and this quick lunch generally provides more pleasure as well as nutrition than a Western-style sandwich.

The *ekiben* is a special delight of long-distance train travel. These train *bento* boxed meals, with disposable chopsticks, offer culinary specialties of particular regions of the country, and can be purchased in shops inside large train stations, on platforms or from a food and beverage cart passing up the aisle of super-express trains.

Above Festive *bento* are available for New Year parties.

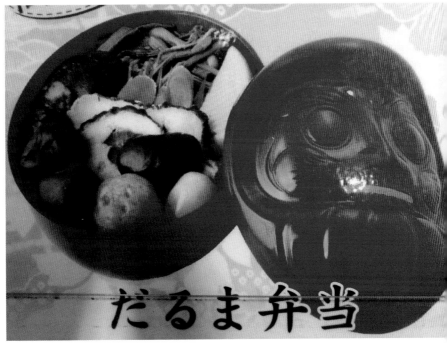

Far left *Bento* packaging celebrates the new Hayabusa bullet train.

Left A boxed lunch of specialties from Aizu Wakamatsu in Fukushima Prefecture.

Right A lucky Daruma doll serves as packaging for a *bento* from Gunma Prefecture.

だるま弁当

onsen

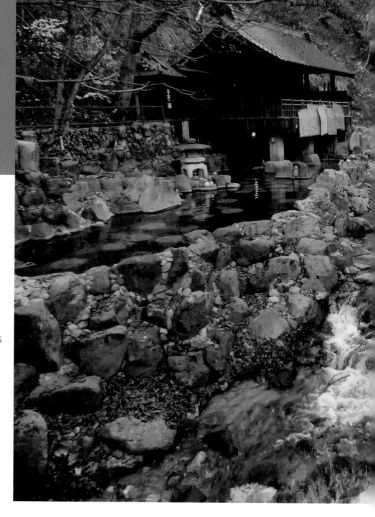

The bath is integral to daily life in Japan, based on the tradition of cleanliness that arose from the essential state of purity encouraged by the native Shinto faith. It is also a customary way to relieve stress and worries.

Hot spring (*onsen*) bathing has been popular for centuries, most likely stemming from observations of wild animals healing their injuries in thermal pools, or of warriors healing their battle wounds in remote and secluded mountain fastnesses. Until today, hot springs are highly regarded for their healing properties.

In this mountainous, volcanic land, spots of thermal activity number in the tens of thousands, some 2,000 of which have been

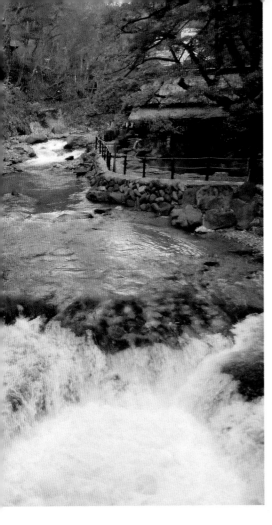

harnessed and opened for guests. The thermal activity fuels water springs and mud and hot sand baths. The mineral content and temperatures vary. *Onsen* are often located in particularly scenic locations. Sometimes an open-air bath (*rotenburo*) is ideally nestled among trees with a grand view or nearby ski slopes.

In combination with comfortable and inviting inns serving delicious local dishes, hot springs attract numerous travelers who wish to be healed or simply to relax.

Opposite
Takaragawa Onsen in Tochigi Prefecture offers a cluster of open-air baths along the Takara River.

Below An open-air bath (*rotenburo*) in Tochigi Prefecture framed with snow.

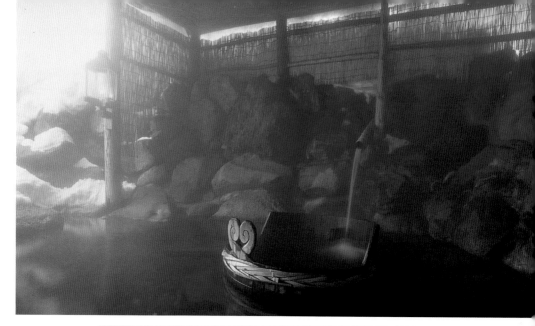

Above A decorative tub at Aoni Onsen in Aomori Prefecture. Without electricity, it is nicknamed the "Lamp Onsen."

Right Hot sand baths in Beppu, Kyushu.

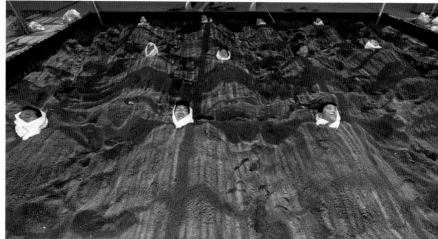

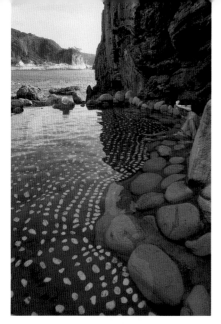

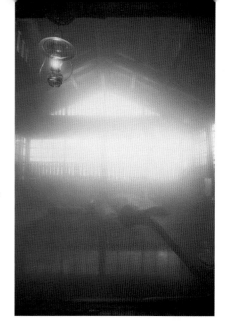

Left A public open-air bath near the port on Kozushima, an island belonging to Tokyo.

Right A petroleum lamp gently lights a bath at Aoni Onsen in Aomori.

Right An open-air bath is situated at the edge of frozen Lake Akanko in Kushiro National Park, Hokkaido.

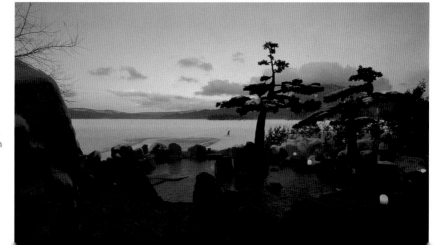

rice

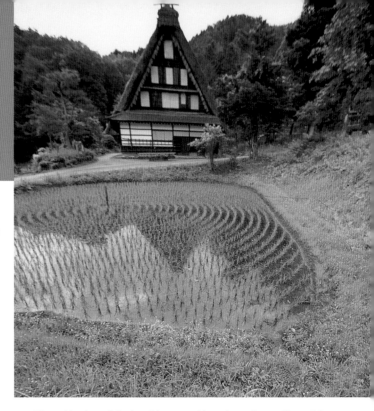

Rice has been cultivated in Japan since the Yayoi era (300 BC–AD 300), more than 2,000 years ago, and is such a staple in Japanese cuisine that breakfast is called "morning rice," lunch is "midday rice" and dinner is "evening rice." Rice was long used as a currency, and taxes were paid by the *koku*, a measure that equaled the quantity of rice needed to feed one person for a year.

Rice consumption has decreased greatly during the past several decades, yet today there is hardly a Japanese who does not eat rice at least once a day. For some, no rice means not having eaten.

The cultivation of rice is said to have shaped the cooperative nature of Japanese society because it requires the work of a whole family, in some cases a whole village.

Rice is considered a sacred crop, and prayers and rites are believed

Above A round rice field (*kuruma-da*), in Shirakawago Folk Village, Gifu Prefecture.

Above right Bundles of rice dry in a field.

Right Stalks of new rice hang from a drying rack after the autumn harvest.

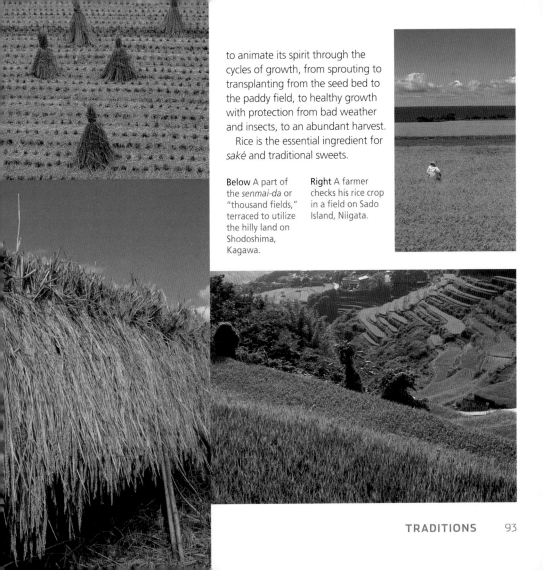

to animate its spirit through the cycles of growth, from sprouting to transplanting from the seed bed to the paddy field, to healthy growth with protection from bad weather and insects, to an abundant harvest.

Rice is the essential ingredient for *saké* and traditional sweets.

Below A part of the *senmai-da* or "thousand fields," terraced to utilize the hilly land on Shodoshima, Kagawa.

Right A farmer checks his rice crop in a field on Sado Island, Niigata.

ryokan

Left Well-worn *geta* sandals await guests off a room's veranda for walks in the garden of a Kyushu inn.

Right The pond of an inner garden at the same Kyushu inn.

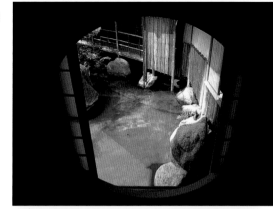

The inn (*ryokan*) is a traditional accommodation expressing the spirit of Japanese comfort and hospitality, with a history dating back to the Nara period (710–94) when people such as *daimyo* or overlords needed places to stay on their way to visit the halls of power in either Kyoto or later Edo, or along the way on religious pilgrimages.

The room floor is woven straw *tatami* and the bed is a heavily padded *futon*. A communal bath is basic, but private ones are not uncommon today. Regional culinary specialties are usually the main treat, often served privately in the guest's room or sometimes in a dining room on individual small serving trays or table-ettes.

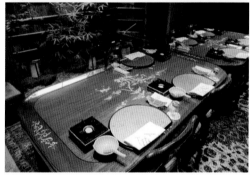

Above A dining table at a *ryokan* in Tokyo's Ueno district features a Western-style table with a Japanese-style setting.

Right A cluster
of old inns at
Ginzan Onsen
in Yamagata
Prefecture.

Left This corridor
in an Ueno inn
displays the subtle
quality of light
seen through reed
shades and paper
shoji screens.

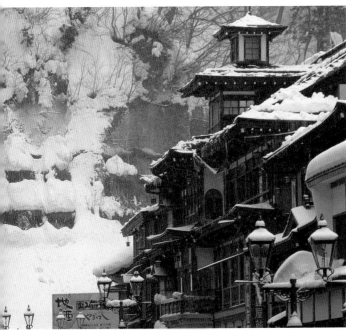

Above right
A room with bedding arranged for a family at an Ueno inn.

Left The view out of the dining room of a small private inn in Tokyo.

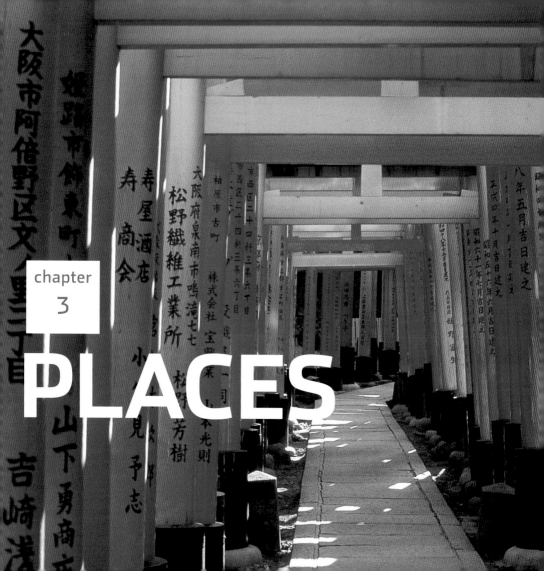

chapter

3

PLACES

昭和六十二年五月吉日建之

昭和六十年六月吉日建之

昭和六十年二月吉日建之

四十九年五月吉日建立

大阪市西淀川区歌島二丁目

平成二年十月吉日建之

平成七年一月吉日建之

The Japanese archipelago stretches nearly 3,000 kilometers northeast to southwest. Places to visit include significant governmental, cultural and historical centers as well as recreational locations. Some of these are "must see" while others are enjoyable destinations for local and foreign visitors. They include centers for art, sites of pilgrimages, hot spring retreats, national parks and, recently, World Heritage Sites. For the young and young-at-heart, there is a variety of amusement parks scattered all over the archipelago.

A "tunnel" of offered *torii* gates at Kyoto's Fushimi Inari Shrine.

old tokyo

The Japanese are more enamored of the new than the old and often ask why foreigners like "all those old things." In the days of old Edo, Ueno was the "high city" of the powerful and affluent. The second *shogun* was advised that the castle and city needed protection from the geomantically ill-favored northeast, the direction of the so-called "devil's gate" from which evil spirits (bad luck) might enter, and thus a great Buddhist temple complex, Kanei-ji, was built in Ueno. Sadly, due to many fires, the battles of 1868 between the *shogun's* loyalists and imperial forces, and the later bombings of WW II, all that remains

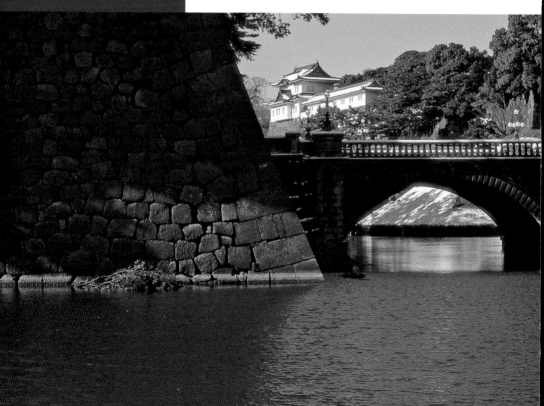

to be seen is a five-tiered pagoda.

Alongside the former high city there is the "low city," *shitamachi*, of the common folk. Bits and pieces of that remain, epitomized by Asakusa. Among foreign visitors, it is a favorite quarter of the city to observe traditional ways of life accompanied by shopping for traditional souvenirs.

Opposite A view across a moat to Nijubashi Bridge and Edo Castle.

Below A huge paper lantern hangs at the entrance to the famous Kannon Temple in Tokyo's Asakusa district.

Above A bronze lantern marks one gate to Asakusa's Kannon Senso-ji Temple.

Right The names of *sumo* wrestlers and their sponsors hang in front of the *sumo* arena during a tournament.

Right A "tunnel" of offered Shinto *torii* gates stands at Tokyo's Nezu Shrine.

Below The entrance to a *saké* bar.

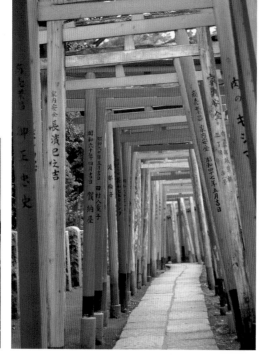

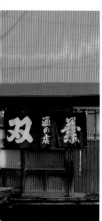

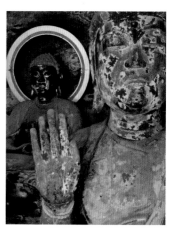

Right The entrance to a festival (*matsuri*) museum in an Asakusa street.

Top A monk stands at the Kannon Temple gate collecting alms.

Above A statue of Amida Buddha in a small Ueno temple.

Right A bridal couple takes a *jinrikisha* ride in Asakusa.

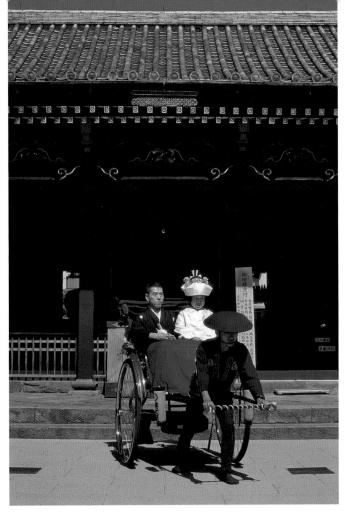

The oldest Buddhist temple in the city, Senso-ji, is home to the Asakusa Kannon, the statue of the goddess of mercy that, in the seventh century, fishermen famously caught in their net. They took it to their lord who enshrined it in his house and later in a hall built for it near the Sumida River, where it is still possible to enjoy an evening on a traditional leisure boat (*yakatabune*).

Commerce and religion are typically intertwined on Nakamise, the inner avenue of shops and stalls that lead to the temple. Once upon a time in this neighborhood, the sacred and the profane impolitely bumped up against each other. People then came here from all over Edo for the assortment of entertainment available—from puppet theater to jugglers, acrobats, so-called "song theater," cinema, *kabuki*, even exotic birds, performing monkeys and wild animals such as lions and tigers, and in the dark alley bars round about, less wholesome activities.

A few other small pockets of nostalgia remain in the neighborhoods of Yanaka, Nezu and Mukojima, all slowly disappearing as they are being replaced by modern architecture.

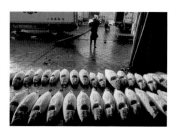

Above Rows of tuna at Tsukiji fish market.

Below A pet dog sits beneath the statue of Hachiko in Shibuya.

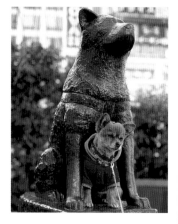

Left Portable shrines gathered in front of Senso-ji Temple in Asakusa for the Sanja Matsuri festival.

Right *Fugu* (blowfish) lamps hang at the entrance to a *fugu* specialty restaurant in Asakusa.

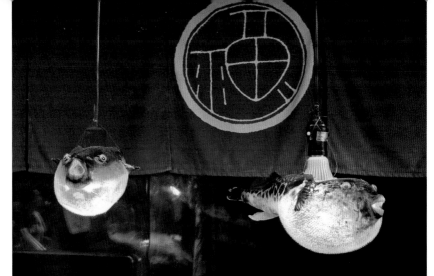

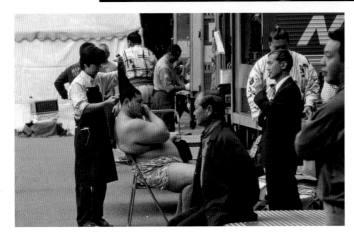

Left A *sumo* wrestler has his hair styled for a tournament at a small arena at Yasukuni Shrine.

Above Buddhist angels (*hiten*) decorate the ceiling at Asakusa's Senso-ji Temple.

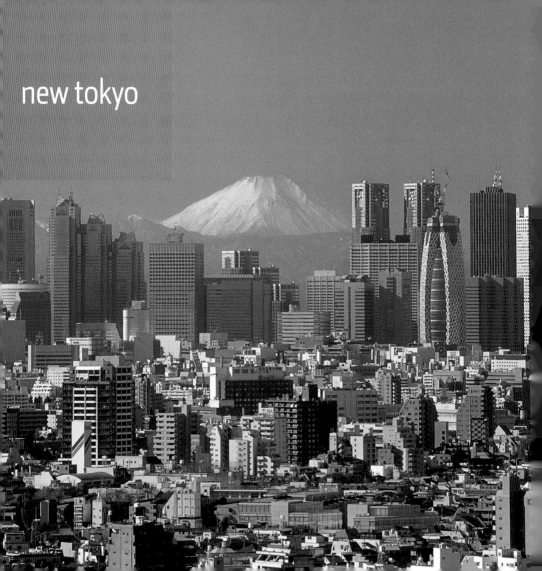

new tokyo

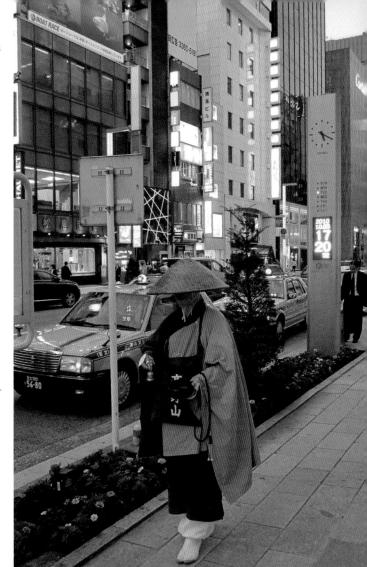

Left A view of West Shinjuku, with Mount Fuji in the distance.

Right A Buddhist monk collects alms on Chuo-dori in the shopping district of Ginza.

Tokyo, the capital city of Japan, has a population of 13 million within a radius of 60 kilometers. The city is a jigsaw puzzle of 23 wards, a mosaic of several mini-cities, each of them diverse and seeming to savor their own social style, stature or the budget of their visitors.

Ginza was the original "new Tokyo" during the Meiji era (1868–1912), the first place to absorb Western influences. After the area was razed by fire in 1872, the lost buildings were replaced by brick ones that lasted only until the first strong earthquake leveled them. It was in Ginza that cafes and pastry shops were first enjoyed, mostly during the following Showa era (1926–89), along with the first taste of Coca-Cola®. There were beer halls and milk halls, where those Western beverages became well known. Also dance halls, where

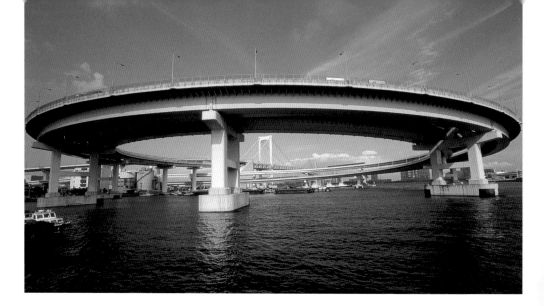

young men could learn and practice Western dances with taxi dancers. The stylish Ginza version of "hanging out" was called *gin-bura*. Long infamous for the world's costliest land prices, Ginza is a constantly changing cityscape; a building seems to disappear overnight, and the next day a new one has gone up in its place.

Alongside the long-standing, pricey and reputable mainstay department stores, where for decades mostly affluent matrons have done their serious shopping, new luxury brand shops built mainly in the early 2000s have been attracting a younger clientele, mostly single career women, turning Ginza into a cosmopolitan Western-style shopping district, a lookalike of those in almost any part of the world.

Roppongi, a popular international party retreat, is dominated by Roppongi Hills and its Mori Tower, topped with a contemporary art gallery and a viewing platform.

Nearby stands the 333-meter-high Tokyo Tower, built in 1958, which was replaced by the 634-meter-high Tokyo Skytree, the tallest tower in the world, when it was opened to the public in May 2012.

Midtown is a chic futuristic development in the Roppongi area, a dynamic compound of yet more enticing shops and classy restaurants, luxurious living spaces, galleries, art and design installations, a garden and a hotel, and across from it all, the New National Art Center.

Opposite Rainbow Bridge over Tokyo Bay leading to the Odaiba waterfront.

Left Reflections of the surrounding buildings in the windows of the Tokyo Metropolitan Government Building in Shinjuku.

Left Shinjuku's Cocoon Building from a nearby subterranean staircase.

Below left Harajuku musicians on Sundays.

Below The Cocoon Building designed by Kenzo Tange's Studio.

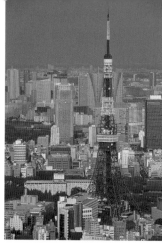

Shinjuku translates as "New Lodgings" because long ago it was a rest stop for travelers on the way into old Edo. These days, more than two million commuters pass through the Shinjuku train station daily. In the 1970s, clusters of high-rise buildings arose in West Shinjuku. From a distance it offers an impressive skyline that, on a clear day, may also include distant, towering Mount Fuji. In 1991, the new Tokyo City Hall (Tocho) was added to the Shinjuku skyline.

Far left Traffic on a Shibuya street.

Left Tokyo Tower rises above the city.

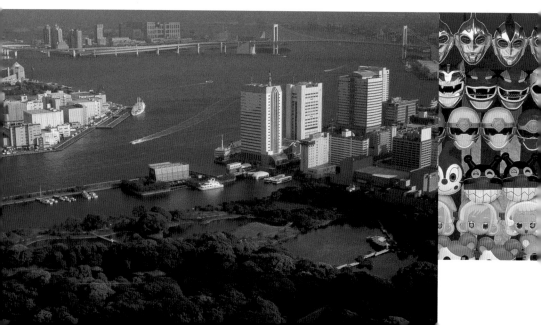

Shibuya is not new in the sense of architecture, but is a gathering place for the youth of the city and the surrounding prefectures and a major nightlife area. The youth meet at the Hachiko dog statue, then climb the slope that was once covered with tea plantations but is now covered with fashion boutiques. Or they hop on the train to one more station, Harajuku, a youth fashion mecca. If the product or style is new or young, it can be seen in either of these two places.

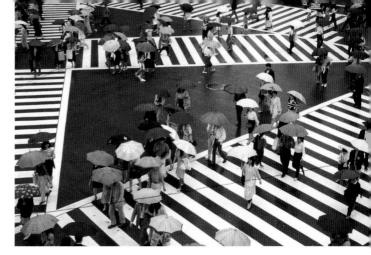

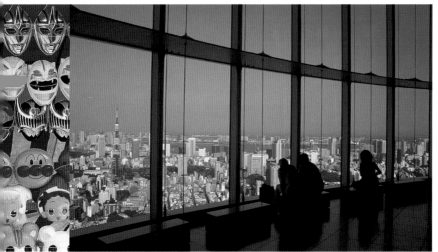

Above Shibuya Crossing on a rainy day.

Far left Tokyo Bay behind Hama Rikyu gardens.

Center left Masks of popular animation characters for sale at a festival stall.

Left A panoramic view of the city from the Mori Art Museum observation deck.

yokohama

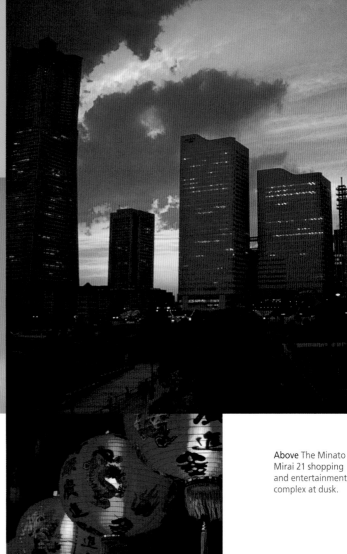

Above An old lighthouse at Sea Bass Pier where commuter boats dock at Yamashita Park.

Right The red lanterns of Chinatown's restaurants.

Above The Minato Mirai 21 shopping and entertainment complex at dusk.

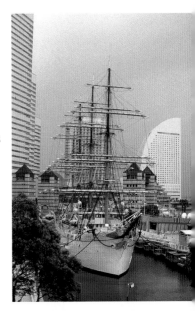

The one-time fishing village of Yokohama opened as an international port in 1859, strategically chosen for being close enough to, or far enough away from, the capital of Edo to suit the interloping Americans and the formerly isolationist Japanese, respectively. Foreign negotiations and trade were conducted there. The cultures, products and trends of the world were also brought in there and disseminated to the rest of the nation. The until-then unknown life of the Japanese spread also to the world, first through *ukiyo-e*, colorful woodblock prints, and later through photography. The first camera entered Japan via Yokohama. In fact, by the end of the nineteenth century, photo postcards were the biggest moneymaker there. The lifestyle of the

Above right The retired sail training ship *Nippon Maru*, moored at Minato Mirai.

Right Kanteibyo, a temple dedicated to the guardian deity of Chinatown.

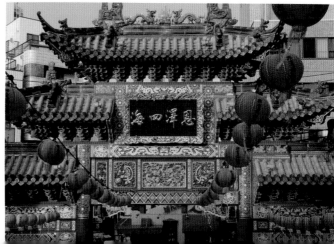

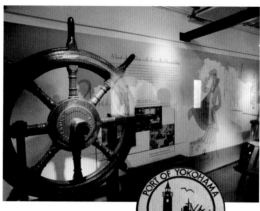

Far left The one-time luxury trans-Pacific liner *Hikawa Maru*, now retired and serving as a museum.

Left Displays of voyages through the *Hikawa Maru*'s history.

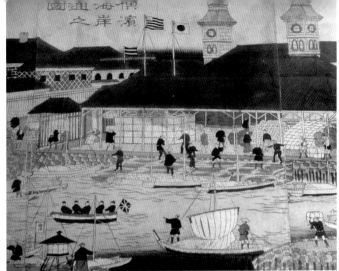

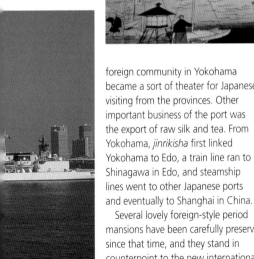

Below A panorama of Yokohama Harbor.

foreign community in Yokohama became a sort of theater for Japanese visiting from the provinces. Other important business of the port was the export of raw silk and tea. From Yokohama, *jinrikisha* first linked Yokohama to Edo, a train line ran to Shinagawa in Edo, and steamship lines went to other Japanese ports and eventually to Shanghai in China.

Several lovely foreign-style period mansions have been carefully preserved since that time, and they stand in counterpoint to the new international city, Minato Mirai 21, built for the new century. It boasts the nation's tallest building, Landmark Tower, and another landmark for youth, the Cosmo World Ferris Wheel, attractively lit at night.

Left One of several historical diplomatic residences preserved in the city.

115

kamakura

Nestled in a curve of wooded hills along the shores of Sagami Bay, about 45 kilometers southwest of Tokyo, the town of Kamakura was for 150 years of the twelfth to fourteenth centuries the military capital of unified Japan. Minamoto Yoritomo was the first *shogun*.

The guardian Shinto shrine of the Minamoto clan, Tsurugaoka Hachimangu, is set in the heart of the city. Its avenue of ornamental cherry trees make spring a magical time to visit. Its spring and autumn festivals, with their votive dancing performances and archery competitions, attract large crowds. On weekends this is a popular venue for wedding ceremonies. The shrine has long been renowned for an impressively beautiful thousand-year-old gingko tree that was a historical landmark but was sadly uprooted in 2010 by strong winds.

Around Kamakura city are dotted a number of austere Buddhist temples, some of which welcome visitors for seated meditation (*zazen*). The symbol of the city, and sometimes even of Japan itself, is the sitting Daibutsu, the 12-meter-high Great Buddha at the Kotoku-in Temple. It is weathered to a gray-

Above A view of the iris garden at Meigetsu-in, the Full Moon Temple.

Right The Daibutsu or Great Buddha at cherry blossom time.

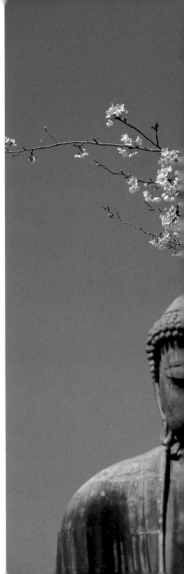

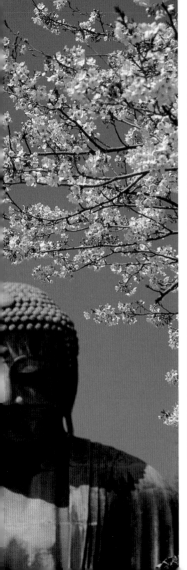

green patina because it has sat in the open air since a tsunami swept away its sheltering building in the fifteenth century. Usually a crowd stands burning incense at the cauldron in front of it, or posing for souvenir snapshots.

This "little Kyoto" is a favored quick escape from Tokyo, with some pleasant hiking trails in the hills. In summer, Kamakura's beaches are extremely crowded, and year round the local waves are a popular place for wind surfers.

Below The beach of Shonan, across from Enoshima island.

Right Komyo-ji, one of the largest Zen Buddhist temples in the city.

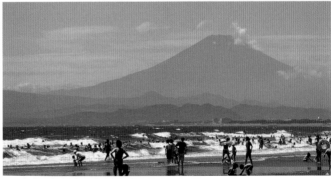

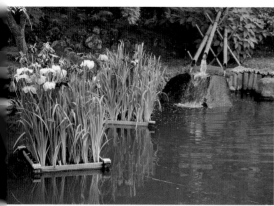

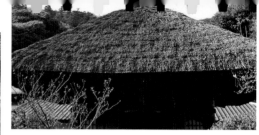

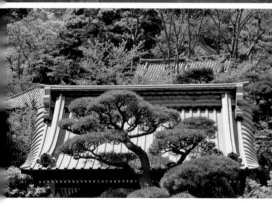

Top The iris pond at the Buddhist Hase-dera Temple.

Above The roofed gate of Hase-dera.

Top right The straw roof of the Zen Buddhist temple Jochi-ji.

Right The view of the city and bay from the terrace of Hase-dera.

Right A temple bell at the secluded Zen temple Kaizo-ji.

Far right A Nio guardian at the temple gate of Sugimoto-ji.

Below A Buddha statue in front of Tokei-ji's iris garden.

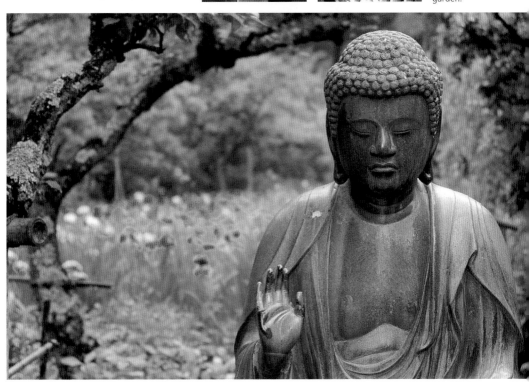

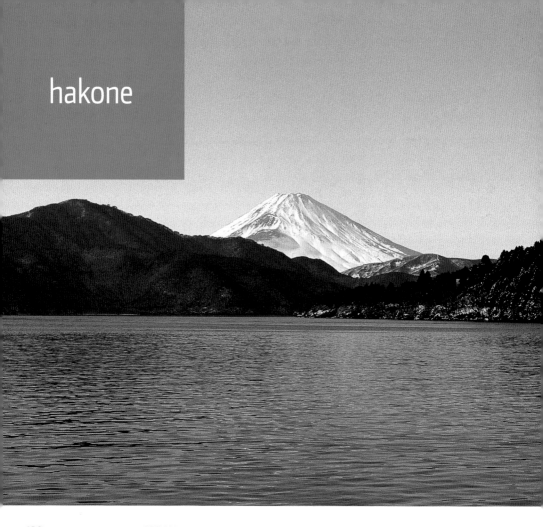

hakone

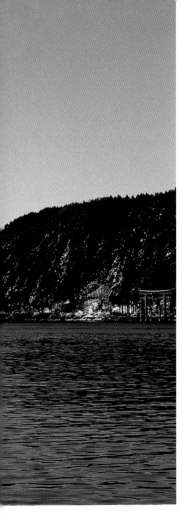

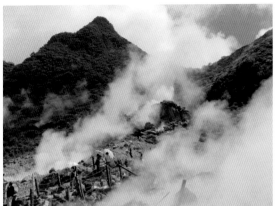

Left Lake Hakone with snow-covered Mount Fuji and the vermilion *torii* gate of a lakeside Shinto shrine.

Above Fumes from thermal activity rise from Hell Valley (Jigoku Dani) in this area of many hot springs.

This resort area in the mountainous Fuji-Hakone-Izu National Park west of Tokyo is a popular day trip or weekend destination, and a splendid viewing spot across a picturesque lake to Mount Fuji. The Hakone area is rife with volcanic hot spring baths in scenic natural settings.

In the Edo period (1603–1868), Hakone was a security guard post, called the Hakone Barrier, on the Tokaido road linking Kyoto and Edo.

The *shogun* enforced a law whereby regional rulers were forced to keep residences in the capital to house their wives and daughters, and themselves to make only annual visits from their home provinces. It was basically a hostage situation that was strictly enforced through stringent inspections at this check-point. Attempts to bypass the inspections were punished by death for men and severe public shaming for women.

Historic hotels and inns, some as many as several centuries old, attract holidaymakers. Culture lovers also particularly enjoy a visit here for the variety of excellent museums.

nikko

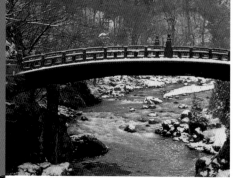

Above A carving of a lucky crane decorates the beam of the corridor Goku Roka within the splendid Toshogu Shrine.

One of the most popular day trip destinations from Tokyo is to this mountain town in Nikko National Park. Some go to enjoy the hiking trails or the abundant natural beauty, such as Lake Chuzenji and the dramatic Kegon Falls, while others head for the shrines and temples, the most famous of which are the Toshogu Shrine, the resting place of Tokugawa Ieyasu, the first *shogun* and great unifier of Japan, and the nearby Taiyu-in Temple with its mausoleum of the third *shogun*, Tokugawa Iemitsu. Toshogu Shrine is profuse with ornamental carvings, perhaps the most popular among visitors being the monkey trio depicting the proverb "See no evil, hear no evil, speak no evil" and the "Sleeping Cat."

In Japan's oppressive summer heat, tourists love to visit Nikko for the cool cedar forests and alleyways and the fresh mountain air; in autumn for the colorful leaves; in winter for the fairytale look of winter snow on the trees and buildings, and year round for the thermal spring bathing and mountain cuisine.

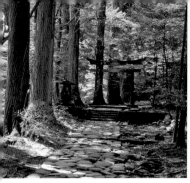

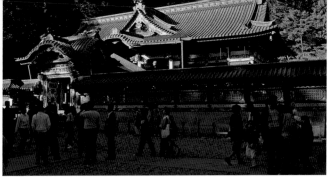

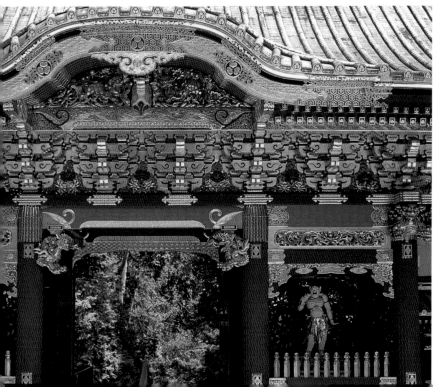

Above left The good luck stone *torii* gate marks the entrance to Takino-o Shrine. Worshipers must successfully toss three pebbles in succession through the small hole at the top for a wish to be fulfilled.

Above Toshogu Shrine with its Yomeimon and Karamon Gates.

Left The richly ornamented Yasha Mon Gate at Taiyu-in-byo, the mausoleum of Tokugawa Iemitsu, grandson of Tokugawa Ieyasu.

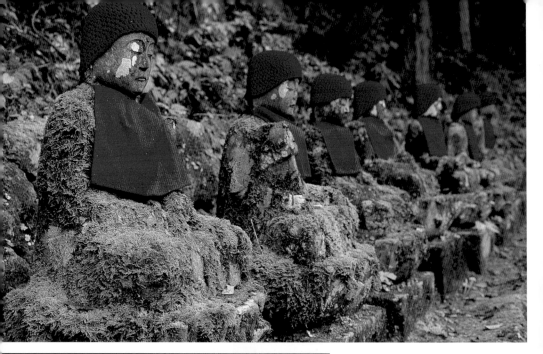

Above Narabi Jizo, a row of about 100 statues of Jizo, the guardian deity of children, stands along the Daiya River.

Left The colorful latticework fence surrounding Toshogu Shrine.

Right San-Jinko, one of three buildings for the storage of festival equipment and costumes.

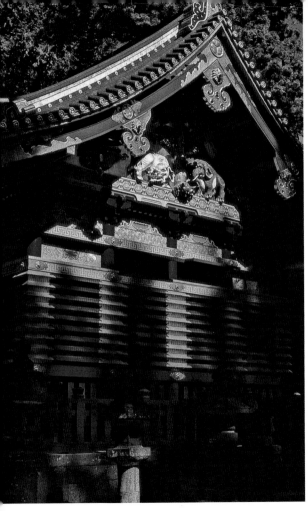

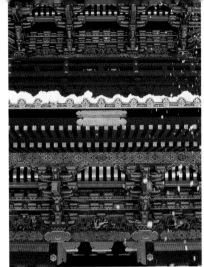

Above A part of a five-story pagoda in snow, with carvings of the twelve animals of the Chinese zodiac.

Right One of the guardian statues at the Yasha Mon Gate.

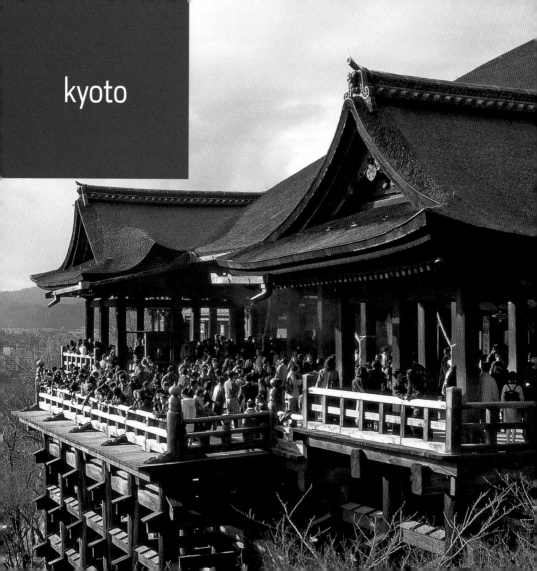

kyoto

Right Pontocho from across the Kamo River.

Left The stage-like terrace at Kiyomizu Temple, here filled with worshipers at New Year.

Kyoto is twelve centuries old and was home to the imperial court for more than ten of them. In 794, it was established as Japan's capital under the name Heian-kyo, and it remained the capital until the transfer of the imperial court to Tokyo in 1869. Considered by many to be the heart of Japan, there is no other place in the country that possesses such a wealth of history, beauty and culture. Neither is there any place so richly imbued with the spirit of Japanese tradition, refined during the celebrated Heian era (794–1185).

The Kyoto of old was patterned after the Chinese T'ang Dynasty capital Ch'ang-an. Sadly, none of the original imperial buildings have survived, although a very small part of Shinsen-en, the ancient imperial Divine Spring Garden dating from around the year 800, still exists in the heart of the city.

Kyoto's many imperial gardens evoke a past of courtly elegance and arranged beauty which tantalize the imagination. The shore of the South Pond at Sento Imperial Palace is paved with tens of thousands of smooth beach stones, a gift from a

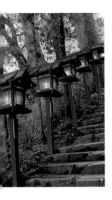

provincial *daimyo* whose retainers presented them at the palace, each stone individually wrapped in silk. At Shugakuin, a painting of carp in one of the guest villas is covered with netting, for guests of the past complained that the fish would leave their place on the wall and swim noisily in the adjacent pond, disturbing their sleep. In the quiet surroundings of Kyoto Gosho, the Imperial Palace, one can almost

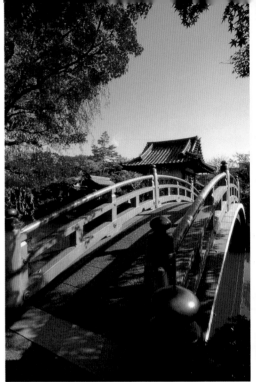

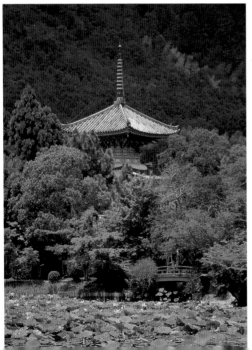

Left The pagoda of Daikaku-ji Temple can be seen beyond the lotus pond.

Above left Lantern-lit steps lead up to Kibune Shrine.

Above A red drum bridge arcs over the pond at Shinsen-en, the Divine Spring Garden.

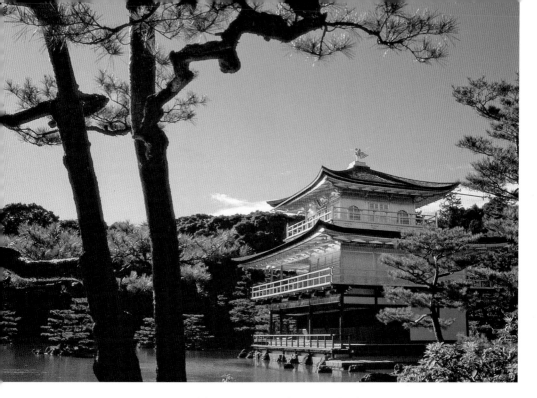

Above Kinkaku-ji, the Golden Temple, stands at the edge of Mirror Pond.

Far right A bamboo grove at Rakusai Bamboo Park.

Right Zen Buddhist vegetarian cuisine (*shojin ryori*) is arrayed on trays at a temple restaurant

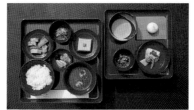

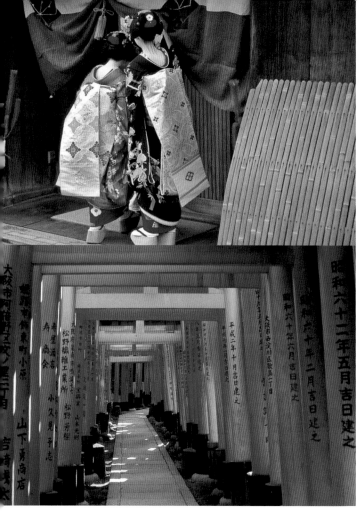

Left *Maiko* pay their respects at the teahouse where they are employed.

Left below A "tunnel" of offered Shinto *torii* gates winds its way up the mountain at Fushimi Inari Shrine.

envision the ancient nobility enjoying their elegant pastimes, such as pleasure boating, moon viewing and poetry competitions. As the imperial seat, the most exquisite arts and crafts developed here to supply the demands of the nobility.

Once upon a time, the only temples permitted to be built within the city walls were To-ji and Sai-ji, the two imperial temples, which assured divine protection of Kyoto. Although Buddhism has the dominant presence in Kyoto, with nearly 1,600 temples, Shinto also accompanies Kyoto people through their lives, and there are some 400 Shinto shrines in the city.

The people of Kyoto worship the Shinto deities with many wonderful festivals (*matsuri*). Two of Japan's oldest and finest, Aoi Matsuri and Gion Matsuri, are celebrated here with spectacular processions and related rituals which vividly express the ancient grandeur of the city.

Beyond the imperial and spiritual legacies of Kyoto, a large part of the city's allure is its temporal attributes. *Geiko*, as *geisha* are known in Kyoto, and their apprentice *maiko*, have for several centuries given Gion and other entertainment quarters an uncommon aura of romance.

In all the world, no more than a handful of cities possess such a tremendous wealth of the ages as does Kyoto. Traditional values continue to hold sway here, and customs long practiced still endure.

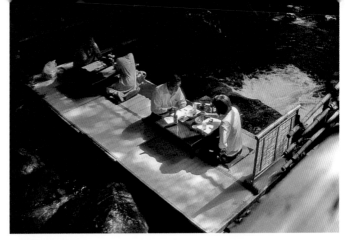

Above Dining al fresco over the river on a terraced platform (*kawadoko*) in Kibune, in the north of the city.

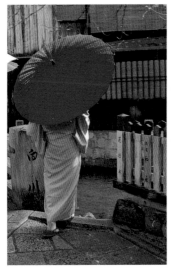

Left A *geisha* (*geiko* in Kyoto) out and about in her neighborhood of Shimbashi.

Above The garden gate at Musha-no Koji Senke Tea School.

Right Evening terrace dining on the Kamo River side at Pontocho.

Below Pleasure boats (*yakatabune*) wait on the bank of the Oi River in Arashiyama.

Below A street in the Pontocho entertainment district at night.

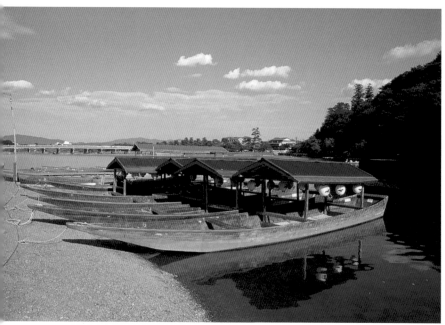

Right The 200-year-old pickle shop "Narita," which specializes in *suzuki-na*, the delicacy of pickled turnip leaves.

Far right A lotus in bloom at the temple pond of Daigo-ji.

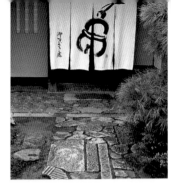

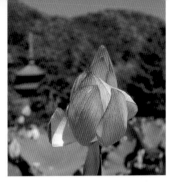

Below A waitress carries a basket of classically styled dishes across the pond to refined specialty restaurants (*ryotei*) on the other side of Hachijogaike.

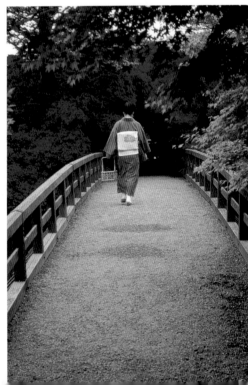

nara

Nara, as the ancient cradle of Japanese civilization, is superb in so many regards—history, art and nature!

Heijokyo, Citadel of Peace, was built in 710, somewhat styled after the Chinese capital Chang-an. It was the period when the Yamato Japanese were eager to learn from their highly advanced continental neighbor, China.

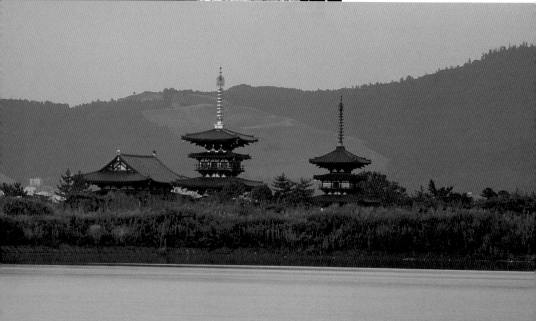

Left Decorative banners mark a temple celebration at the great Buddhist temple Todai-ji.

Right Lucky monkey doll charms (*sarubobo*) for sale at a Naramachi souvenir shop.

Right At Kasuga Taisha, lighted bronze Mantoro lanterns show their motif of sacred deer.

Below A *jinrikisha* comes to a halt in the merchant district of Naramachi.

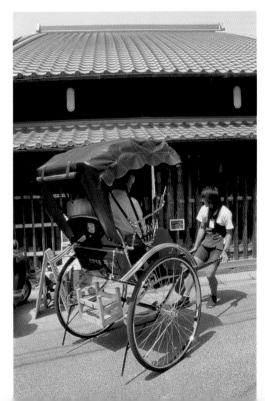

Finally, in 724, it was Emperor Shomu's turn to rule. Putting all his faith in Buddhism, as did his equally devout Empress Komyo, he dedicated himself to building temples and monasteries and strove to create a Buddhist nation. His greatest project was a magnificent seated statue of Buddha some 15 meters in height. The casting of the Great Buddha of Todai-ji Temple, undoubtedly the best known of Nara's abundance of treasures, was completed in 752 and today remains the largest bronze casting in the world, while the structure that shelters it is the world's largest wooden building.

Left Yakushi-ji Temple, with its two pagodas, stands next to the large pond O-Ike at dusk.

Nara Park is home to some 1,000 tame deer, an animal deemed sacred since the guardian deity of the important Fujiwara clan was reputed to have arrived in Nara riding on the back of a deer in ancient days. This vast primeval forestland in the city seems almost magical, and there is more to be found outside the city, making Nara Prefecture an oasis of green. One can imagine that in those places, the ancient deities of nature still reign. Spending time there, among the sometimes mysterious rocks and trees, often interpreted as "power spots," can be spiritually healing.

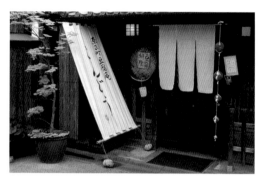

Left A calligraphic banner and a *noren* curtain mark the entrance to a Naramachi restaurant.

Below The Daibutsu or Great Buddha still inspires worshipers after thirteen centuries.

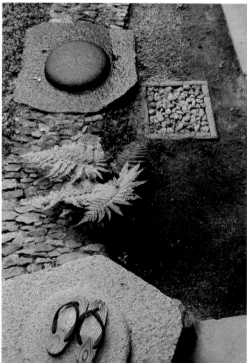

Far left The *machiya* style architecture of merchant houses in Naramachi.

Left The inner garden of a *machiya* townhouse.

Right A Noh offertory dance is performed during the On Festival.

Right A storehouse (*kura*) attached to a residential house.

Far right A water basin for worshipers to cleanse their hands at the Gango-ji Temple.

Below A *futogoshi* fence protects a house from deer damage, while *sarubobo* monkey charms hang in front to bring good luck to the house.

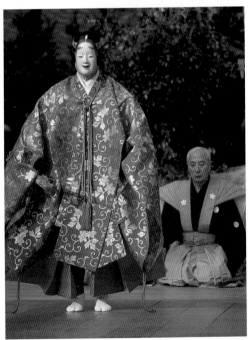

osaka and kobe

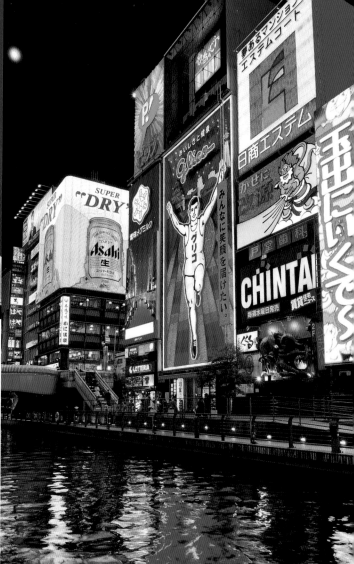

Above The puppet theater of *bunraku*.

Right The lively Dotombori entertainment district along one of the old castle moats.

Opposite above Osaka-jo, the castle built in the seventeenth century, was partially restored in the twentieth century.

Opposite below Two chefs prepare for the evening's business at their *sushi* bar.

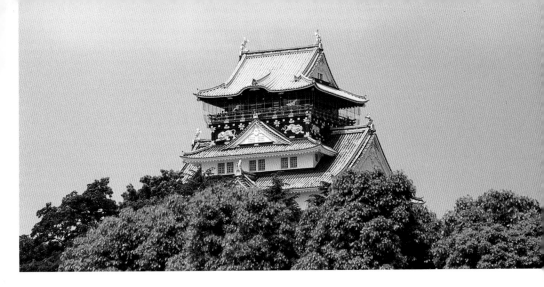

Osaka was early Japan's first small capital, known as Naniwa-kyo, from the year 645 when Emperor Kotoku built his palace there. In the fifteenth century, the name was changed to Osaka, meaning "large slope." Osaka was, for a long time, Japan's most important economic center, being one of the ports through which trade was conducted with China.

In the late sixteenth century, the "great unifier" of Japan's various provinces, Toyotomi Hideyoshi, built Osaka Castle. During the ensuing Edo period (1603–1868), the city served as the distribution center for the rice

gathered as the shogunate's rice tax, and became known as *taiko-no daidokoro*, the "nation's kitchen." Osaka is a city renowned for its citizens' passion for eating well. It is filled with many good restaurants, and they attract much domestic food tourism from elsewhere in the country. After Tokyo and Yokohama, Osaka is the business hub of western Japan.

The nearby city of Kobe also served as a port for early commerce with China. After a long period of national isolation, the country was opened to international trade during the Meiji

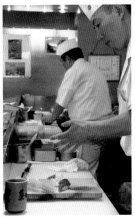

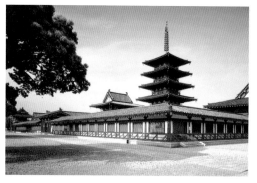

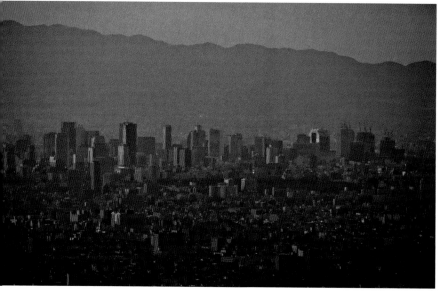

Above left The sixth-century Buddhist temple, Shitteno-ji.

Above Taiko-en Yodogawa-tei, a classically styled elegant *ryotei* restaurant set in an Osaka garden.

Left A panoramic view of Osaka from a Nara Prefecture mountaintop.

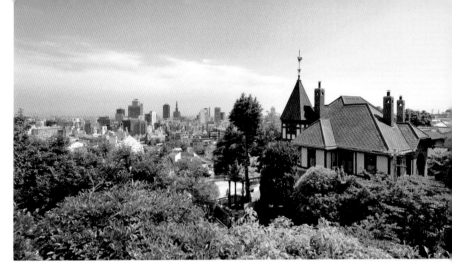

Right Kobe's leafy Kitano district, where more than 100 foreign-style homes were built in the early twentieth century.

Below Weathercock House is among the historical foreign residences in Kobe's Kitano district.

Below right A pot of Kobe beef *sukiyaki* simmers on a restaurant table.

period (1868–1912). A Foreigners' Settlement was established. Western goods and ways of life entered Japan through the port of Kobe. Here there developed an industry of confectionary and beef that still remains important to this day. Jazz and movies are reputed to have entered the country through the port. A community of foreigners built their Western-style homes in the Kitano district. Many are still preserved and are popularly visited by Japanese tourists to the city for their "exotic" atmosphere.

Kobe is remembered for the great earthquake that caused much damage to the city and its citizens in 1995.

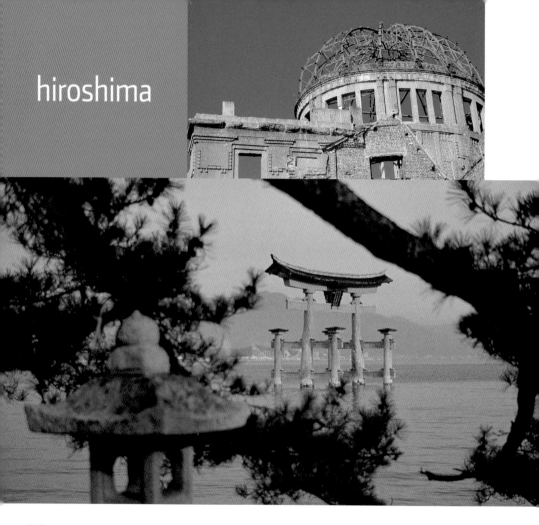

hiroshima

The name of this city is familiar around the world for a tragic reason—the atomic bombing of 1945. That story and its aftermath are memorialized in Peace Park, with its skeletal Peace Dome, a museum, cenotaph and the Flame of Peace.

The city stands on the edge of Seto Naikai, the Inland Sea. Offshore is Miyajima, Shrine Island, home to one of the nation's most strikingly beautiful Shinto shrines, Itsukushima Jinja, nearly a thousand years old. A 16-meter-tall red *torii* gate rising from the sea, which appears to float at high tide, marks this as a sacred place.

The island offers pleasant hiking and dramatic panoramas as well as good dining, with locally cultivated oysters a specialty.

Above left Genbaku Domu, the Atom Bomb Dome, that will forever stand as a memorial to the tragic bombing of the city near the end of World War II.

Left The sacred *torii* waterside gate of Itsukushima Shrine.

Right The Atom Bomb Dome stands by the side of Motoyasugawa River.

Far right At low tide, deer roam beneath the drum bridge at Itsukushima Shrine.

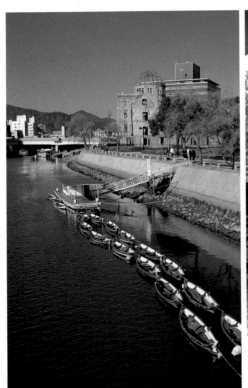

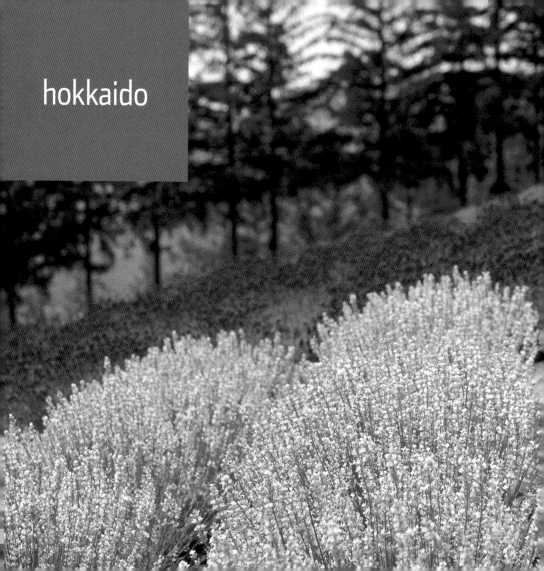

hokkaido

Hokkaido, formerly known as Ezo, is Japan's second largest island, yet only about 5 percent of the nation's population lives here. Its vast, open rolling fields are dedicated to agriculture and, with the occasional red-painted barn, are reminiscent of American farmlands. Hokkaido is known for its corn and other grains, potatoes and dairy products. Colorful flower fields, particularly of sunflowers and lavender, are a great tourist attraction.

There are five national parks on the island, several mountain ranges, many thermal spring baths (*onsen*) and excellent ski resorts. The island's boundless nature is home to much wildlife. The red-crowned crane (*tancho*) probably attracts the most attention. This magnificent bird, an admired symbol of longevity, winters in Hokkaido and travelers come

from afar to watch it feeding and performing its mating dances.

Hokkaido is home to the Ainu, an aboriginal group that long ago migrated to the Japanese archipelago, most likely from either Central Asia or Siberia. In the Ainu's re-created tourist villages, visitors can learn about their lifestyle, music, dance, handcrafts and religious beliefs.

Hokkaido is a popular destination for its cool, dry summers and some atmospheric European-style brick buildings.

Left The lavender fields of Furano.

Above right A trio of farmers harvest lavender in mid-summer.

Right In Otaru, a fishing and coal mining town, the Otaru Canal is a transportway through a nineteenth-century warehouse district, some now turned to modern uses.

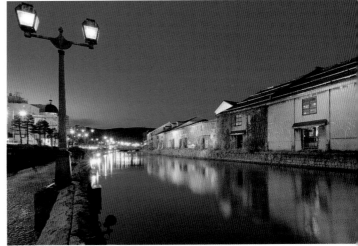

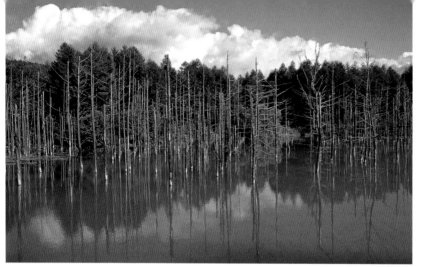

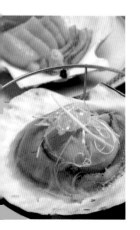

Above Biei's Aoi Ike ("Blue Pond"), recently created by damming a river to prevent possible mudflow in case of volcanic activity, in Mount Tokachi.

Left A fresh, raw scallop is served as part of a platter of *sashimi* at a Hokkaido restaurant.

Right Red-crested cranes (*tancho*) gather for winter feeding.

Above Sapporo's annual Yuki Matsuri or Snow Festival.

Above right Niseko is a cluster of ski towns with slopes internationally known for good powder snow.

Right Toya-ko, a caldera lake in Shinkotsu-Toya National Park, is a popular summer getaway in cool Hokkaido.

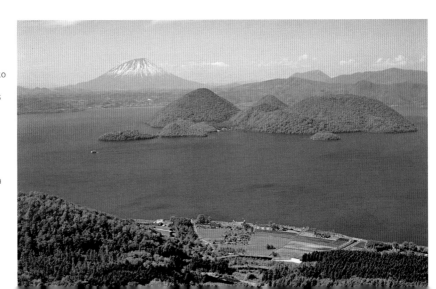

okinawa

The far-flung Okinawan Islands were once known as the Ryukyu kingdom. They were strongly influenced by their proximity to continental China as well as to Japan. The capital was Shuri, near Naha, where the stunningly beautiful Shuri Castle, reconstructed in the twentieth century, is a World Heritage Site.

The Ryukyus long maintained their independence by paying tribute to China. But in the early seventeenth century, a powerful clan that ruled the south of Japan's main southern island, Kyushu, invaded the Ryukyus and bled them dry with taxation. Eventually, when the feudal system was outlawed, the Japanese government annexed the two dozen islands that make up the group and made them their southernmost prefecture of Okinawa.

During World War II, or the Pacific War as the Japanese prefer to call it, Okinawa was used as a protective barrier against American attack on Japan's main islands. The people there suffered terribly from the fighting and from starvation. Many were pressed to commit mass suicide by Japanese soldiers before the Americans could invade. Post-war, the islands were occupied by American forces and

Far left A beach scene on Ishigaki Island.

Center left Chiri Umi Aquarium at Expo Ocean Park showcases local sealife.

Left Shuri Castle, first built in the fifteenth century, stands partially restored in Naha.

Left An Okinawan musician takes a break from playing his *shamisen*.

Above Shuri Castle is ornately and beautifully decorated.

became a convenient site for their military bases to monitor military activities in Asia. Local citizens have mixed feelings about the long-continuing American presence. On the one hand, they would prefer that the rest of Japan bear some of that burden, while on the other they appreciate the benefits it brings to their weak economy. In 1972, Okinawa reverted back to Japan.

Okinawa has become a very popular tourist destination because of its tropical climate, beautiful beaches and interesting cultural features. For the domestic tourism market, it is an exotic destination with the advantage of being officially "Japanese." Locals can enjoy some of Okinawa's American-ness without having to travel abroad.

Some of Okinawa's more distant islands are said to have the most

attractive beaches and more authentic Ryukyu culture and are easily accessible by local plane or ferry networks. Among these scattered Okinawan islands are tropical rainforests, attractive traditional architecture, wonderful white sand beaches, coral reefs waiting for snorkelers and excellent dive sites. For those who prefer to enjoy under-water beauty at a distance, there is also a popular local aquarium.

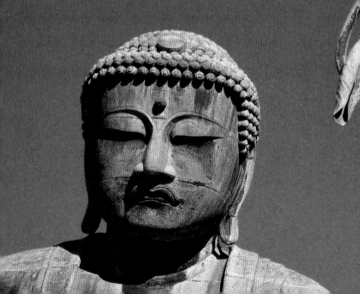

chapter 4

SPIRITUAL LIFE

The blend of indigenous Shinto and imported Buddhism is a font for a great wealth of customs, acts and objects that since ancient times have been a part of worship. The Japanese, although they often declare themselves to be "not religious," very naturally lead their lives accompanied by the gods, and much of what they do is a ritual in itself. Many visitors find this topic to be one of the most fascinating among Japan's cultural themes. For those with such an interest, there are many training centers for Zen meditation or Shugendo mountain worship, which also provide suitable accommodations for their students.

The Kamakura Daibutsu or Great Buddha is accented by a lotus sculpture.

buddhism

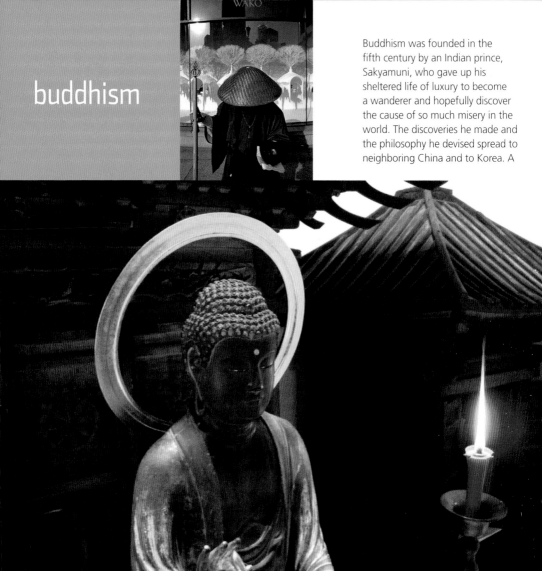

Buddhism was founded in the fifth century by an Indian prince, Sakyamuni, who gave up his sheltered life of luxury to become a wanderer and hopefully discover the cause of so much misery in the world. The discoveries he made and the philosophy he devised spread to neighboring China and to Korea. A

thousand years later, a Korean king sent a gilded image of Sakyamuni to the Yamato court in Nara.

In the earliest years of Buddhism, it was considered more respectful to not attempt to craft the Buddha's visage. He was represented by an often stylized image of his sacred footprint, which is what was said to have been left behind when he reached enlightenment and left this earth. Such footprint reliefs remain in many Asian countries, including several examples in Japan. Here, Buddhist temples (*o-tera*) followed the styles early travelers and disciples had seen in China, but eventually they took on a more Japanese aesthetic. Today, there are about 75,000 Buddhist temples in Japan.

The historic Buddha, Sakyamuni, is known as Shaka in Japan. There are other Buddhas or manifestations of Buddha besides Shaka. The most influential of these among the Japanese is Amida, Buddha of the Pure Land, who attends to the souls of the departed; Yakushi, or the Buddha of Healing, who offers health, longevity and fulfillment of wishes to his worshipers; and Dainichi, the Cosmic Buddha, who illuminates the universe.

Opposite above A monk collects alms from passersby at Ginza Crossing.

Opposite below The newly restored Amida Buddha statue during its "Eye Opening Ceremony" at the Gugyo-ji Temple in Chiba Prefecture.

Above Buddha's Footprints are incised in stone at the Denzu-in Temple in Tokyo.

Left A statue of the bodhisattva Jizo-san, protector of children and travelers, dappled with the shadows of foliage.

Below A statue of Nyoirin Kannon sits pensively on a lotus throne.

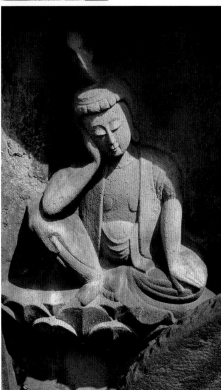

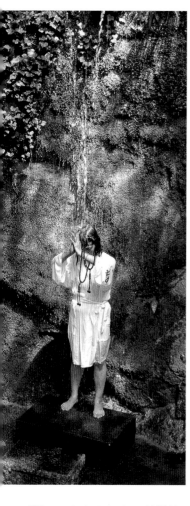

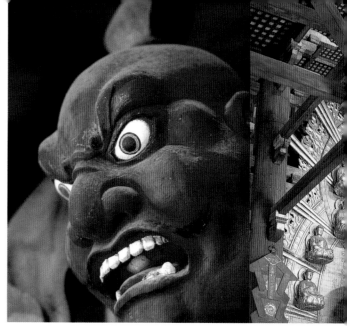

As the historic Buddha was a prince, on occasion Buddha may be depicted in a princely fashion. Most often he is presented as a monk dressed in a simple robe, exhibiting the most important of the 32 distinguishing features he was said to possess in life, such as a wisdom protuberance at the crown of his head, long earlobes, three fleshy creases on his neck and a wispy curl on his forehead. He is generally depicted seated or standing on a lotus pedestal, a plant that is a potent symbol of the faith, rising as it does from mud yet producing a blossom of great beauty and purity.

Among Japan's countless splendid sculptural and pictorial images of Buddha are a number that, for their beauty, age and significance, have been designated national treasures. The most famous are the Great Buddha of Todai-ji Temple in Nara,

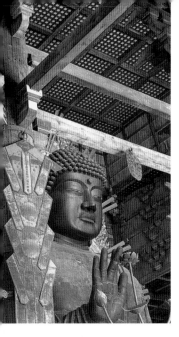

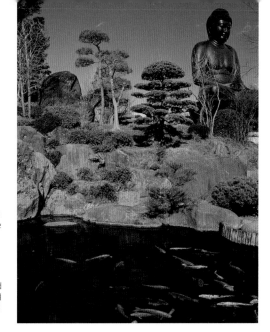

Far left A worshiper performs ablutions at a waterfall on Tokyo's Mount Takao.

Center left One of two fearsome Nio guardians at a temple gate.

Left The eighth-century Nara Daibutsu or Great Buddha sits majestically in the ancient Todai-ji Temple.

Right Tokyo's little-known Daibutsu is seated near the *koi* pond at Tokyo's Joren-ji Temple.

dating from the eighth century, and the Great Buddha of Kamakura, dating from the thirteenth. Both are so often pictured that they have become symbols of this country, recognized throughout the world.

Alongside the Buddhas, the Buddhist pantheon also includes bodhisattvas (*bosatsu*), which are guardians and vanquishers of evil, beings who have delayed their imminent enlightenment to instead remain on earth and help others attain entry to the heavenly realm. They are frequent focuses of Buddhist worship. The goddess of mercy, Kannon, is a bodhisattva who is entreated with prayers and wishes. Myriad figures of Jizo can also be seen across the country, in and around temples, in graveyards, and along roadways and paths. Dressed in a monk's robe, Jizo is often depicted holding a staff in one hand and a sacred jewel in the other. Sometimes he is portrayed as a child-monk, as chubby and innocent as the little ones he has vowed to protect. Among the many remaining bodhisattvas, all "specialists" in the endless variety of mankind's troubles, is Miroku, known as the Buddha of the Future, who is promised to come some billions of years hence to bring salvation to all sentient beings on earth.

Below Buddha statues at Kyoto's Joruri-ji Temple.

Bottom A Buddhist monk rings a bell as he collects alms on a city street.

Right This painted image of the bodhisattva Jizo-san wears a bib offering inscribed with a prayer, at Rashomon, the old gate to Kyoto.

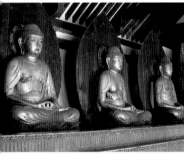

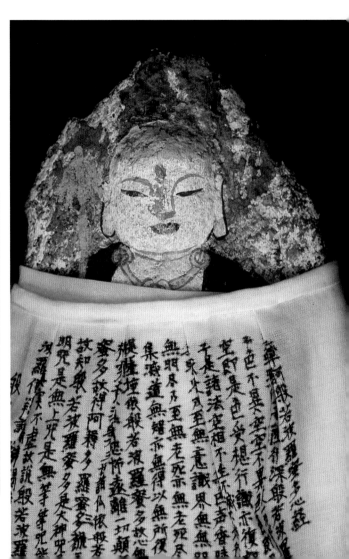

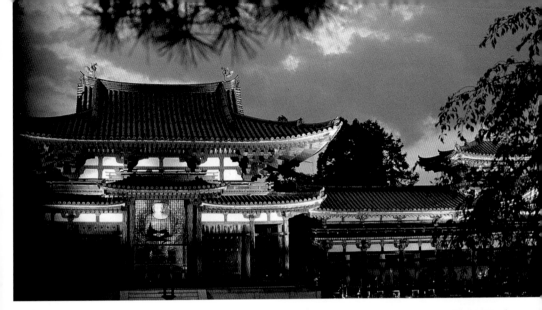

Above Kyoto's Byodo-in Temple is illuminated for a festive ceremony.

Left A Jizo-san statue wears an offered string of prayer beads in the Kyoto garden, Shinsen-en.

Right A golden figure of Yakuyoke Amida Buddha, protector against evil spirits, at Kamakura's Hase-dera Temple.

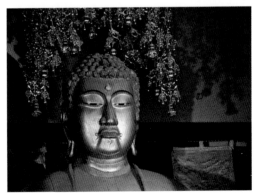

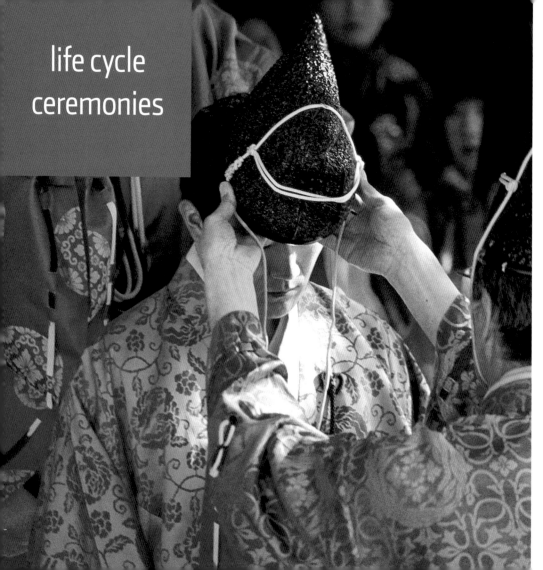

life cycle
ceremonies

Left A young man receives a ceremonial hat (*eboshi*), a mark of his adulthood, at Meiji Shrine's Coming of Age ceremony in Tokyo.

Right Small oil lamps illuminate statues of the bodhisattva Jizo-san during the celebration of Jizo-Bon at Gango-ji Temple, Nara.

Below right A traditional Shinto wedding is conducted at Tokyo's Meiji Shrine.

on a tray. The soup, fish and rice are symbolically fed to the child by touching the food just to the lips using chopsticks, with the hope that throughout its life it will have enough food and will be able to healthily eat without any troubles.

The ritual of Shichi-Go-San or Seven-Five-Three customarily sees girls at the ages of three and seven, and boys of five taken to the family shrine to be blessed by the priest. They are dressed in their finest clothes, still generally the *kimono*.

At age twenty, a person reaches adulthood, and is formally

The very ritualistic way of life enjoyed by the Japanese means that the milestones of life are formally marked in front of the Shinto gods. During a baby's first shrine visit (*hatsu-miyamairi*), it is welcomed as a Japanese, and as one in a series of generations the baby is presented by the grandparents for blessing at the family's local parish shrine.

Since the Heian era (794–1185), an *okuizome* ceremony of "imitative magic" has been conducted with the roughly 100-day-old teething infant. In this ceremony, a traditional Japanese meal is formally presented

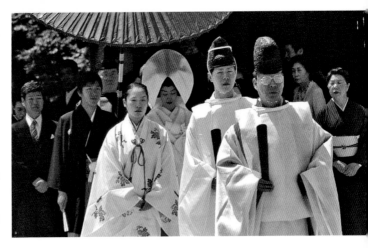

welcomed to society with a rite called *seijin shiki*, held on Seijin-no Hi, Coming of Age Day.

Nowadays, couples often marry in their thirties. A legal marriage requires only registering at one's ward office, so anything else is just for pleasure or sometimes for prestige. A Shinto ceremony may be held. Or sometimes a so-called "Christian" ceremony is chosen with the bride in a fairytale princess-style white wedding gown.

Certain birthdays are celebrated as auspicious, including particularly the 66th, 77th and 88th, which is called *beiju*. More and more of the famously long-lived Japanese are reaching the most auspicious age of all, their 100th birthday!

Passing away is most often marked with a Buddhist funeral ceremony and a series of periodic Buddhist memorial rites.

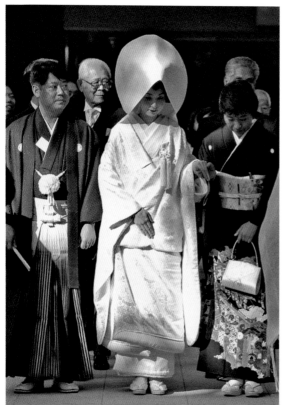

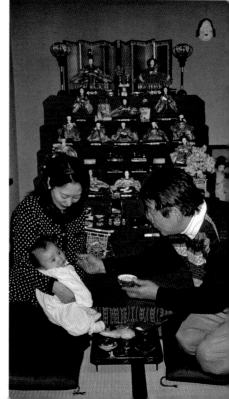

Left A baby at its *o-miyamairi* ceremony, its first shrine visit.

Right A shrine maiden helps the priest carry out the Sansankudo or "Three times three" *saké* sipping ritual during a wedding at Kamakura's Tsurugaoka Hachiman Shrine.

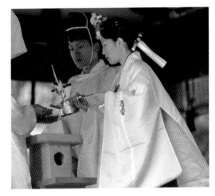

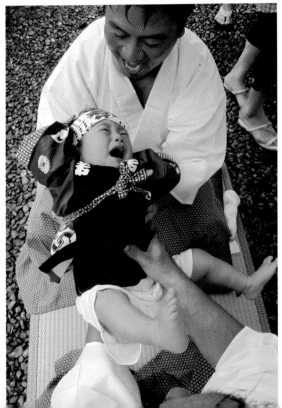

Far left Bridal attire includes the hood-like *uchikake*, which is said to hide a wife's horns of jealousy.

Center left A mother holds her baby while its grandfather symbolically gives a taste of the baby's first traditional food with chopsticks, called *hatsu hashi*, meaning, "first chopsticks."

Left In a ceremony at a Shizuoka shrine, a baby is tossed and turned in the belief it will grow up to be braver.

Below A bride and groom and her mother wait for the wedding ceremony to continue.

SPIRITUAL LIFE 161

festivals

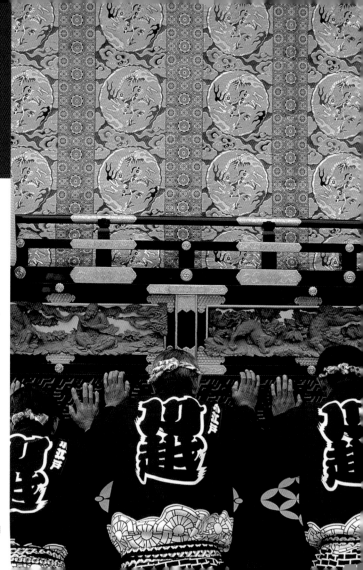

Japan may very well enjoy more festivals than any other country in the world. Participants summon the gods to descend to earth, to mingle and rejoice with them. The Japanese festival, called *matsuri*, is an intimate, joyous encounter with the divine.

Such events embrace both the *matsuri* traditional festivals of Shinto origin and annual rites of Chinese or Buddhist origin called *nenchu gyoji*. Among them are centuries-old, even ancient, practices. Some of the very oldest today endure in the area around Nara and Kyoto, the historical cradle of Japanese culture.

National milestones from the past are also marked with festivals in Japan. Another category of popular celebrations includes re-enactments of legends and historical events.

In order to seek the favor of the gods or spirits, generous offerings are made in the course of events, ranging from food and drink to sacred music, dance and drama.

A festival is frequently a celebration of nature and the renewing cycle of the changing seasons. A great many of the *matsuri* are related to the growing cycle of the vital crop, rice. Throughout the seasons, rites are held, in turn, to petition the gods for a good growing season, to drive away pests and natural disasters which could harm the burgeoning grain, and to give thanks for a bountiful harvest.

Guardian deities of historical clans, villages, towns and districts are also honored at annual shrine rites. Good luck, good health and prosperity are sought through purification of a person or place by rites of fire, smoke, water, mud and sand; through contests and deeds of strength, agility and fortitude; and by shouting, singing or dancing.

Left A child festival attendee in Tokyo is dressed in festive attire.

Right A participant costumed as a Buddha at Osaka's Nembutsu Neri Kuyo.

Below On Miyajima Island, ascetic monks (*yamabushi*) undergo a firewalking purification ceremony.

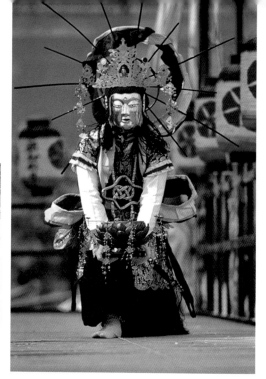

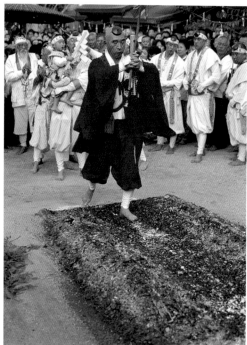

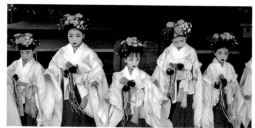

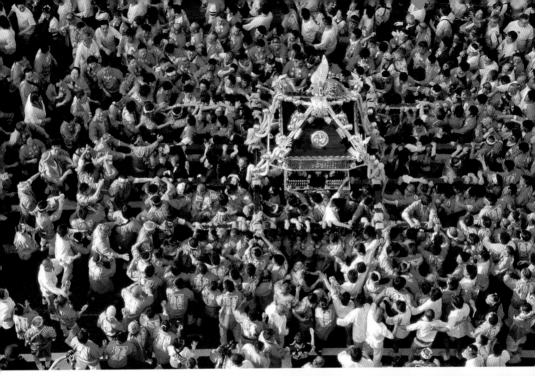

Left Sacred children prepare to perform an offertory dance at Kyoto's Zuiki Matsuri, a harvest festival for local agriculture.

Above Celebrants at Tokyo's Torigoe Matsuri carry and accompany the sacred *mikoshi* portable shrine through the neighborhood.

Right An illuminated float takes part in a parade during Aomori's Nebuta Matsuri.

Left A baby dressed in festival attire accompanies its mother to Tokyo's Sanja Matsuri in Asakusa.

The parading of the *mikoshi*, the elaborate and weighty portable shrine and momentary home of the honored deity, is frequently the highlight of any festival. Rowdily borne through the neighborhood on the heaving shoulders of a multitude of celebrants, this is no solemn procession.

Festivals in Japan customarily constitute acts of worship. In the distant past, when life was difficult for most, well-being seemed wholly at the mercy of the gods (*kami*). Even in these more informed times, the protection and sense of security the *kami* offer still maintain their appeal.

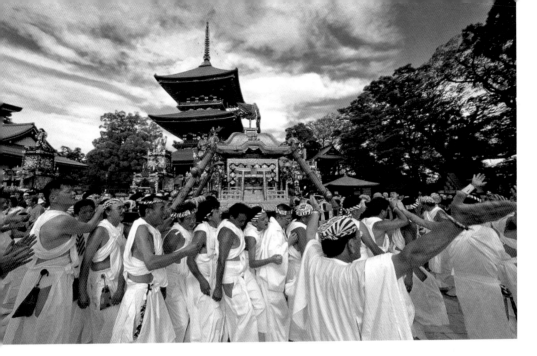

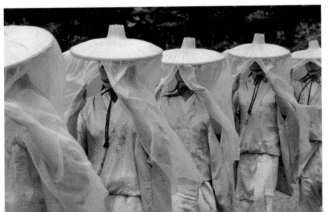

Opposite above Hiwatari, a fire-walking ceremony, is conducted by ascetic monks (*yamabushi*) seen blowing conch shell horns behind the flames, at Chichibu, Saitama Prefecture.

Above Young men carry a *mikoshi* portable shrine at the Gion Matsuri in Narita, Chiba Prefecture.

Left A procession of young women in Akita celebrate the legendary beauty of the historical Lady Komachi.

Left Blessed children (*chigo*) are led to Yasaka Shrine in Kyoto by their fathers during the Gion Matsuri.

Below *Gagaku* musicians perform at Meiji Shrine's Spring Grand Festival in Tokyo.

Right Kyoto's Gion Matsuri procession of floats in the rain.

Below right Shrine maidens (*miko*) bear trays of sea urchins (*uni*) to offer back to the sea during Uni Kuyo, a memorial rite, Shimonoseki.

Opposite The Hadaka Matsuri or Naked Festival celebrates thanksgiving for the abundance granted to Chiba fishermen.

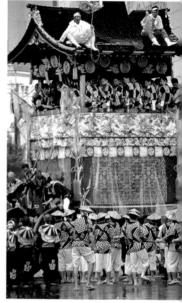

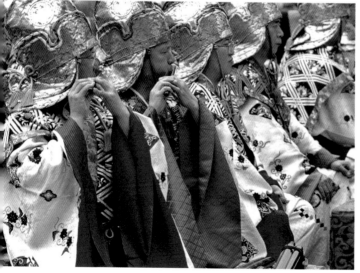

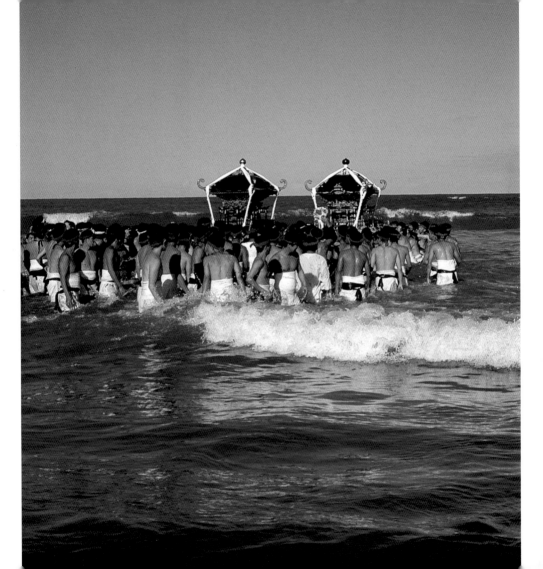

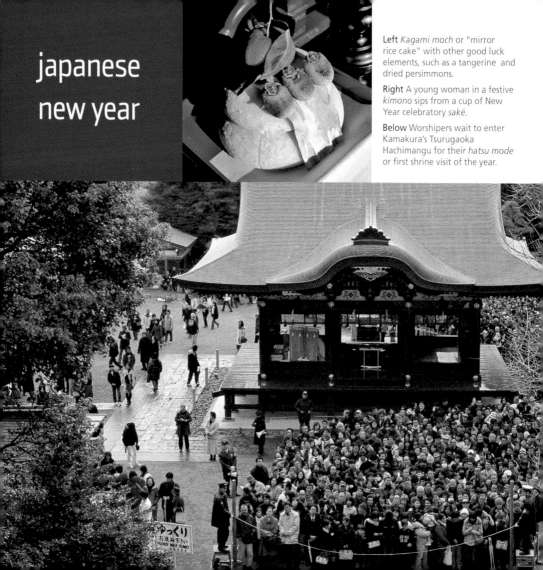

japanese new year

Left *Kagami moch* or "mirror rice cake" with other good luck elements, such as a tangerine and dried persimmons.

Right A young woman in a festive *kimono* sips from a cup of New Year celebratory *saké*.

Below Worshipers wait to enter Kamakura's Tsurugaoka Hachimangu for their *hatsu mode* or first shrine visit of the year.

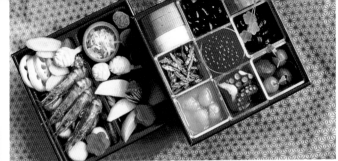

Japanese New Year or O-Shogatsu comprises a huge variety of events, rituals and customs. Weeks before, popular seasonal markets are set up selling traditional decorations and talismans, both secular and sacred. The zodiacal animal of the year is shaped into sought-after collectibles. Other typical decorations include *kadomatsu*, an assemblage of bamboo stalks, branches of pine and plum blossoms, symbolic of hope and prosperity, for display at the house entrance. For above the door there is *shimekazari*, twisted straw ropes adorned with auspicious items of seaweed, dried persimmons and an orange. A similar set is arranged with *kagami-mochi*, round slabs of pounded rice cakes, that can be seen almost everywhere.

Home celebrations also include thorough cleaning of homes and

Above Traditional foods for the New Year holidays (*osechi ryori*), arranged in special boxes, can be purchased in supermarkets or restaurants.

Below A good luck ornament (*shimekazari*) decorates the door of a home.

the preparation or purchase of food called *osechi ryori* for family and visitors. In addition to cleaning, businesses host *bonenkai* parties to bid farewell to the old year.

On New Year's Eve or O-Misoka, after watching popular television shows of singing contests, many people visit Buddhist temples to listen to Joya-no-Kane or the ringing of 108 chimes to dispel bad desires. Early the next morning, they will visit the Shinto shrine of the parish that protects them. Such first visits, or *hatsu mode*, extend over the first three days of the year, and are

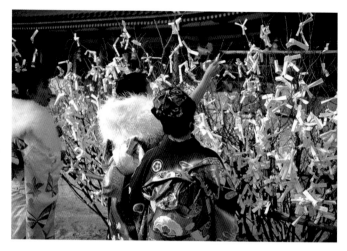

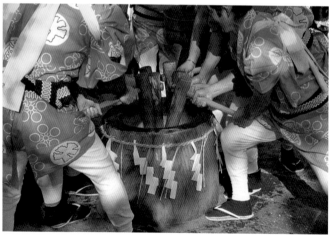

joyous social get togethers and an opportunity to purchase lucky charms, such as evil expelling arrows (*hamaya*) and fortune telling papers (*o-mikuji*). The tradition of watching the first sunrise is commemorated with many other "firsts," such as the first dream, the first calligraphy, the first tea ceremony, the first business transaction, the first surf sailing experience, etc.

From this annual enactment emerges a powerful sense of history, national unity and personal renewal, together with positive energy in all aspects of society.

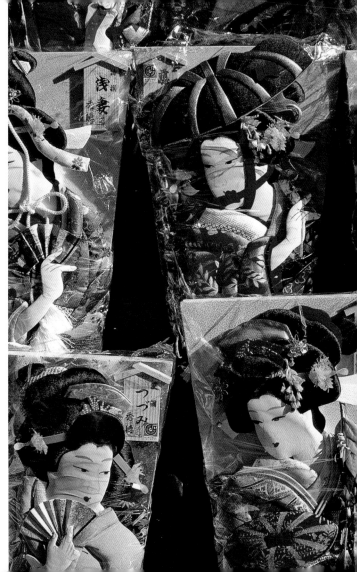

Above left Girls at a temple tie their printed fortunes (*o-mikuji*) to the branches of a tree for the attention of the gods.

Left The male parishioners of a Tokyo Shinto shrine take part in *mochitsuki*, the pounding of glutinous rice into festive rice cakes.

Above *Kadomatsu*, the traditional New Year pine and bamboo decoration at the entrance to a home.

Right At the Asakusa holiday market, various beauties from history decorate the paddles for *hagoita*, the game of battledore, popularly played on New Year's Day in the past.

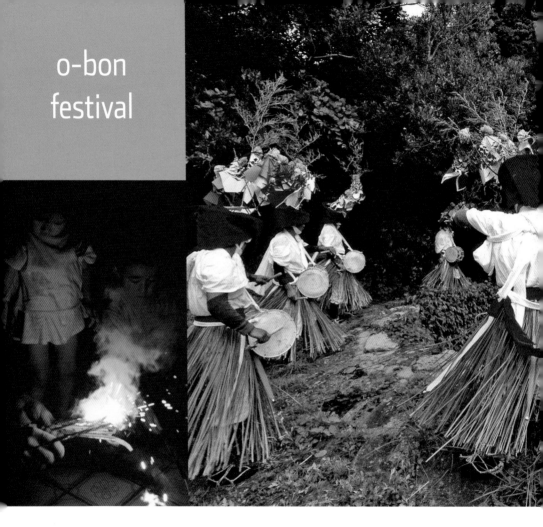

o-bon
festival

Far left Children play with sparklers by an O-Bon "spirit welcoming fire."

Left A grass-skirted procession passes through the village of Tamanoura on Goto Island to welcome the spirits of the ancestors on their summer visit home.

In mid-July or mid-August, depending on the district, families gather to welcome visits from their departed ancestors.

Graves are cleaned and offerings are prepared for this Festival of the Dead (O-Bon). This event of the ancient Chinese Buddhist calendar has been celebrated in Japan since the seventh century. With lanterns or fires to light their way, the spirits of ancestors are welcomed home from the world beyond for a three-day earthly visit. Communities sometimes entertain the visiting spirits with music and outdoor group folk dancing, called *bon-odori*.

Above right Small offerings of, ground cherry pods (*hozuki*) and portions of rice are placed in front of ancestral tablets in a traditional old *minka* farmhouse preserved in Tokyo.

Right Spirits of ancestors are ritually sent off in a "floating of lanterns" ceremony (*chochin nagashi*).

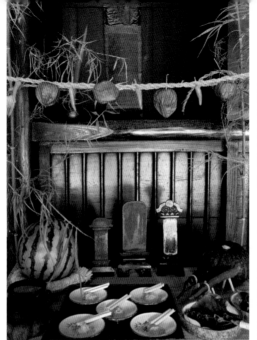

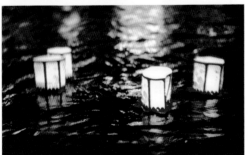

Top Chopped vegetables are served on a woven offering tray for visiting spirits.

Above A Buddhist family altar (*butsudan*) displays photographs and tablets of ancestors, with lanterns and fruit offerings set on a table in front.

offerings

Above The statue of Ninomiya Kinjiro, a symbol of diligence for students, is heaped with offerings of coins given with their prayers.

Left Prayer plaques (*ema*) hang in offering at a shrine.

Right *Saké* and a rice cake stand in offering on an outdoor shrine altar dedicated to the goddess Benten.

Below A doll offering made of taro and five-colored paper to celebrate the placation of an ancient legend about a child-eating snake.

From the simplest, most modest coin tossed into a shrine or temple's offering box (*saisen bako*) to lush seasonal fruit and flowers displayed in front of a temple, offerings are elemental in worship. An offering is almost always given with a prayer because of the reciprocal nature of worship. The gods will do for man, and man does for the gods.

Wooden prayer tablets called *ema* (*e* meaning picture and *ma* meaning horse) are also included by worshipers to convey their wishes to the deities. Once upon a time, an important plea made by a wealthy person might have been accompanied by an offering of a live white horse, one of several animals believed to be messengers to the Shinto gods. In time, people of lesser means sought to modestly emulate this practice by offering a picture of a horse painted on wood. Today, there is hardly a temple or shrine which does not have its own unique *ema* available for purchase and inscription by worshipers, as well as a designated spot for them to be hung as offerings to the deities.

Offerings to the enshrined deity (or deities) are made daily at shrine altars. These are carefully prepared and presented by the priests or their helpers. Generally called *o-sonaemono* (offered things) but in Shinto *shinsen* (food for the gods), these offerings tend to be mainly raw, or sometimes of rather salty or strong taste. The basic Shinto offerings are rice, *saké*, salt, water and *sakaki* (the branch of a sacred evergreen tree). Other foods are sometimes added, such as seafood and vegetables, in accordance with the custom of the shrine. Buddhist offerings, called *kumotsu*, include fruit, flowers, incense and candles and sometimes sweets, or in the case of ancestral offerings on graves, a beverage or food that was a favorite of the deceased, or even cigarettes or, in the case of a child, a favorite toy. Offerings are mainly material, but can also be in the form of an honorary dance, music, a Noh play or a martial art.

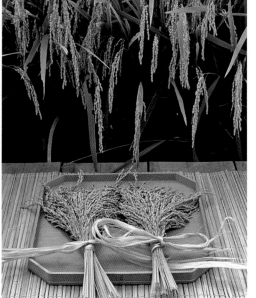

Below In Nara, an offering of deer horns is given during the annual Tsunokiri ritual.

Left Prayer plaques (*ema*) hung for the attention of the Buddha at a Buddhist temple.

Right New rice is offered in the field at Ise Jingu, one of Shinto's main shrines.

Right A lucky sea bream (*tai*) is offered on a shrine altar.

Far right An image of the goddess of the arts, Benten-sama, on a prayer plaque, is caught in a beam of sunlight.

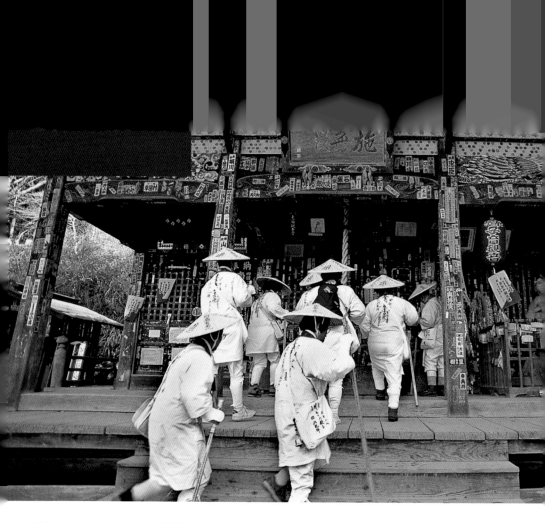

Once upon a time, religious pilgrimages were the only kind of vacation available from the stresses of man's daily life. The earliest ones are thought to date from the eighth-century Nara era and were usually undertaken by ascetic monks, emperors and members of the nobility. Later, they began to be undertaken by the common man, especially farmers, who had seasonal free time.

Junrei refers to the type of religious pilgrimage in which a person makes a circuit of a number of sacred sites in a designated order, traditionally on foot. These days, although some people continue to hike the circuit, many others travel from temple to temple in their own car, while others may hire a taxi, and many more take an organized bus tour.

Most famous is the 88 Buddhist temple pilgrimage on the island of Shikoku. The island of Shodoshima in the eastern Inland Sea has a small circuit of temples. Near Tokyo, the Chichibu Pilgrimage encompasses 34 temples dedicated to the bodhisattva of mercy, Kannon-sama.

Pilgrims (*henro*) customarily carry with them a special book (*goshuin cho*) or a scroll (*kakejiku*) or wear a white cotton vest on which to collect the red temple seals and black calligraphic inscriptions.

Also popular are single site pilgrimages, such as to the peak of Mount Fuji or to the Grand Shrine of Ise, the center of Shinto, or other famous shrines or temples.

Today, part of the attraction of pilgrimages is to escape from urban surroundings to the outdoors. Some pilgrims have moving, even miraculous, stories to tell about the success of their prayers made on pilgrimages.

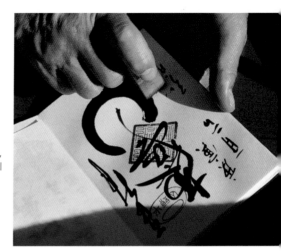

Above A temple priest stamps an inscription in a pilgrimage record booklet (*goshuin cho*).

Opposite Pilgrims arrive at one of the 34 temples on the Chichibu pilgrimage route.

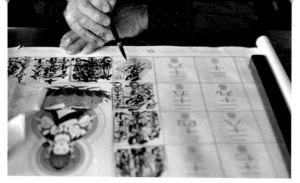

Left A priest inscribes a scroll (*kakejiku*) for a visiting pilgrim.

Below left A pilgrim visiting Miyajima Island in Hiroshima.

Below right Pilgrims often leave their walking sticks, like an offering, at the final temple of the circuit, this one the Chichibu pilgrimage.

Opposite above right Eighty-eight bags of sand, one for each temple of the Shikoku pilgrimage, are touched by pilgrims at a Tokyo temple where it is believed that it is equivalent in blessings to making the real pilgrimage.

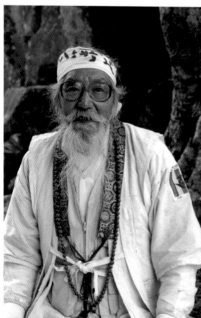

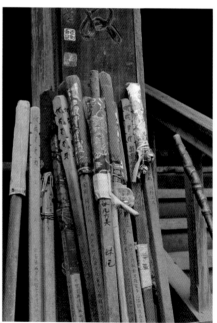

Above A Buddhist priest inscribes a scroll with the temple name on Tokyo's Mukojima district "Seven Lucky Gods" pilgrimage at New Year.

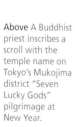

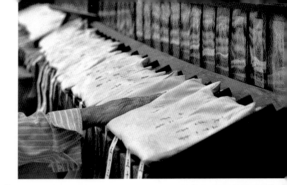

Left A stone marker points the direction of the route on the Chichibu pilgrimage.

Below Pilgrims to the 34 Chichibu temples dedicated to Kannon-sama, the goddess of mercy, in customary attire of hat, coat and Buddhist rosary.

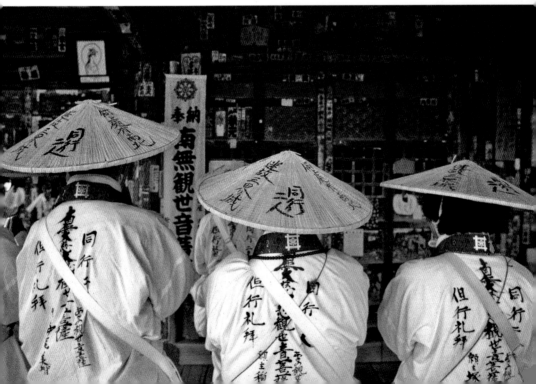

shinto

Japan's indigenous faith is rooted in the remote mists of time. The deities worshiped were called *kami*, and they are said to number in the millions. Originally, the place of worship was nature, an area demarcated in a grove of trees with only the sky overhead. Eventually, the growing popularity of the Buddhist religion, imported from the Asian continent, encouraged the Japanese to give it a name—Shinto ("the Kami Way")—and the impressive temples of Buddhism inspired the people to construct a sacred building (*jinja*) which, in English, is commonly called a shrine. There are some 75,000 Shinto

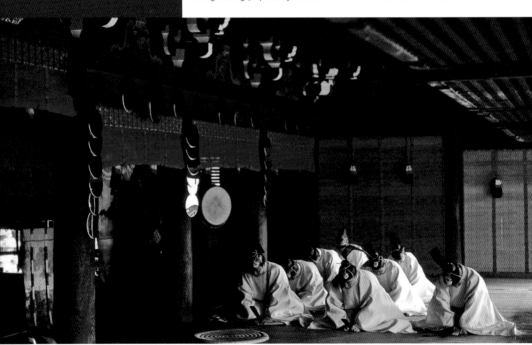

shrines across the country. They are recognizable by the *torii*, the arched gateway that stands in front, separating the sacred ground from the temporal.

The supreme deity and progenitress of the imperial line is Amaterasu-no Mikami, the Sun Goddess, dwelling in her earthly

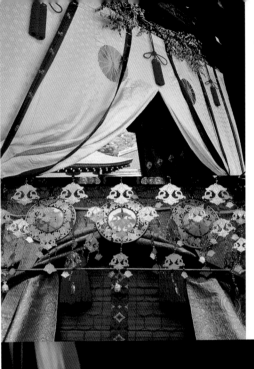

Left The entry to Kyoto's Shimogamo Shrine is draped with a decorative curtain.

Left A richly ornamented portable shrine (*mikoshi*) at a Tokyo shrine festival.

Below A shrine priest waves a staff of white paper strips (*haragushi*) to purify worshipers at New Year.

Above Amulets (*omamori*) are popularly carried inside or tied to handbags, with wishes for good fortune.

Left Priests take part in a ceremony in Kitano Tenmangu Shrine in Kyoto.

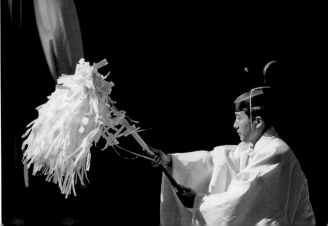

sanctuary, Ise Jingu, the Grand Shrine of Ise, which is the holiest place of Shinto since the fourth century. The Emperor is the Head Priest of Shinto.

Significant moments of people's lives are marked and celebrated with Shinto rites and the blessings of the *kami*.

Shinto worship involves purification, that is, being physically and mentally clean; the presentation of an offering to the god, which may be as simple as a coin tossed into a shrine's offering box before prayer, or more elaborate entertainment, such as traditional music or a sacred dance or the demonstration of a feat of strength or skill; and the expression of gratitude with joyful noise and merrymaking of a shrine festival (*matsuri*).

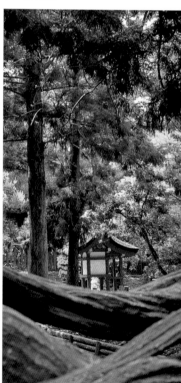

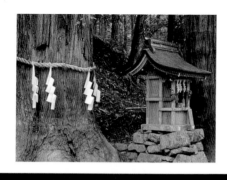

Right A priest purifies sacred *sakati* branches at the start of the water boiling ceremony (*yudate*) at a shrine.

Below The attractive roofline of Ninomya Ebisu Shrine in Kobe.

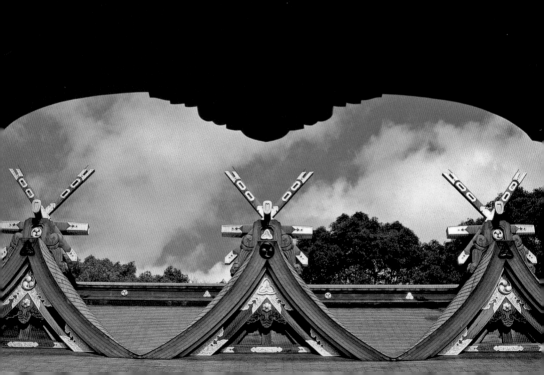

amulets and talismans

Above The year's lucky direction amulet from Tokyo's Fukagawa Fudo Temple.

Right Amulets (*o-mamori*) for sale at the important Buddhist temple, Shinsho-ji, in Narita, Chiba Prefecture.

Below A popular figure of good luck, Maneki Neko, the "Beckoning Cat," on a chart of various sorts of luck.

Right A shrine's display of many different kinds of lucky charm.

The desire for good luck is universal. In Japan, it is believed that the whims of the deities can be influenced by the possession of the proper amulet or talisman, called *o-mamori*. These are popularly purchased at virtually all Shinto shrines and Buddhist temples around the country.

O-mamori are often designed as small brocade bags that enclose a paper inscribed with sacred words. Others may be in the shape of the shrine or temple's well-known sacred treasure, or depict a benevolent deity, such as the Buddhist goddess of mercy, Kannon-sama. Usually attached by string to a handbag, briefcase or school bag, some may be worn on the body or carried in a pocket or wallet.

Displayed for sale, *o-mamori* are labeled for the particular efficacy of each, be it love, money, exam

Right A shrine maiden (*miko-san*) wraps grains of rice in white paper to make lucky charms for the New Year at Tokyo's Dai Jingu Grand Shrine.

Above A lucky charm for a pet at Tokyo's Jindai-ji Temple.

Above Printed fortune papers (*o-mikuji*) are tied up outdoors for the attention of the deities.

success, good health or safe driving. Larger lucky objects to aid in wish fulfillment include the Daruma doll, named for Bodhidharma, the Buddhist monk who brought Buddhism from India to China, and printed papers (*o-fuda*) which are hung to protect the home or other space to keep it safe.

Although most good luck charms are available all year round, others are particularly popular seasonally, especially at the time of the annual entrance exams and at New Year, when thoughts naturally turn to improving one's fortunes.

Left Dried squid (*surume*) is an amulet for good luck in the kitchen.

Right An information technology amulet from Tokyo's Kanda Myojin Shrine popularly attached to one's computer.

Left A charm for *yakuyoke*, dispelling of evil or bad luck, sold at a shrine.

Below *Hamaya*, arrows that symbolically defeat bad luck, are favored good luck charms for New Year.

ACKNOWLEDGMENTS

Special appreciation to Marilyn Kalan Kircher whose stories about Japan enticed us to come here and see for ourselves. Also to Lee Lilya, Anderson family friend, who in the 1950s brought the writer a pair of charming porcelain dolls after his military service in Japan. They awoke the little girl to the existence of the far-off land called Japan. Thanks to friends Hisako Kanehira, Hiroshi Tamaoka and Arata Kawashima for so generously taking the time to answer our endless questions about things Japanese.

ADDITIONAL READING

Any book by Donald Richie, the "grey eminence" among foreign writers on Japan.

A History of Japanese Art by Tanaka Hidemichi, Akita International University Press, 1995.

ABOUT TUTTLE
"BOOKS TO SPAN THE EAST AND WEST"

Our core mission at Tuttle Publishing is to create books which bring people together one page at a time. Tuttle was founded in 1832 in the small New England town of Rutland, Vermont (USA). Our fundamental values remain as strong today as they were then—to publish best-in-class books informing the English-speaking world about the countries and peoples of Asia. The world has become a smaller place today and Asia's economic, cultural and political influence has expanded, yet the need for meaningful dialogue and information about this diverse region has never been greater. Since 1948, Tuttle has been a leader in publishing books on the cultures, arts, cuisines, languages and literatures of Asia. Our authors and photographers have won numerous awards and Tuttle has published thousands of books on subjects ranging from martial arts to paper crafts. We welcome you to explore the wealth of information available on Asia at **www.tuttlepublishing.com**